SURVEY OF
HISTORIC
COSTUME
student study guide

SURVEY OF HISTORIC COSTUME
student study guide

6th edition

PHYLLIS G. TORTORA

SARA B. MARCKETTI

BLOOMSBURY

NEW YORK · LONDON · NEW DELHI · SYDNEY

Fairchild Books

An imprint of Bloomsbury Publishing Inc.

1385 Broadway	50 Bedford Square
New York	London
NY 10018	WC1B 3DP
USA	UK

www.bloomsbury.com

FAIRCHILD BOOKS, BLOOMSBURY and the Diana logo
are trademarks of Bloomsbury Publishing Plc

Fifth edition published 2011

This edition first published 2015

© Bloomsbury Publishing Inc, 2015

ISBN: PB: 978-1-62892-234-9

Typeset by Lachina
Cover Design: By the Sky

Table of Contents

How to Use This Study Guide

This Study Guide accompanying *Survey of Historic Costume*, 6th edition, is designed to help you effectively navigate the text. The Study Guide is not a substitute for the text, but rather a tool to help you identify, synthesize, and retain the text's core information. In order to maximize the benefits of this Study Guide, use the activities presented in each chapter to direct your reading. The key to success in its use will come from your attention to those areas your instructor emphasizes and the notes you take as you read.

Organized in parts and chapters parallel with the book, the Study Guide includes material directly related to the text. Part openers orient you with broad historical context and draw your attention to elements related to all of the periods covered in each part. For every chapter, the Study Guide includes the following sections:

- **Chapter Objectives** are designed to help you focus on what you should know after reading and studying the chapter. You can use these focal points as a framework against which to measure your own learning.
- Familiarity with specialized vocabulary is essential for learning; therefore, **Key Costume Terms** are listed right after the chapter objectives.
- A concise **Historical Snapshot** situates you in time.
- A **Summary of Themes** digests fashion's ongoing interaction with social issues, political events, cross-cultural influences, technological advances, the arts, and religion.

In addition, each chapter includes the following exercises, designed to get you actively engaged with the textbook. Do them on your own, with a partner, or in a study group.

- **Review Exercises** help you to confirm your grasp of basic facts through nuts-and-bolts type questions such as multiple choice, true or false, and fill in the blank.
- **Visual or Primary Source Analysis Exercises** draw your attention to the wealth of color images from the textbook and illustrations reproduced in the Study Guide so that you yourself become a costume historian by looking closely at the sources.
- **Critical Thinking Questions**, keyed to Chapter Objectives, ask you to evaluate, analyze, compare/contrast, create, or apply principles based on your study of the chapter. The designation "CO 0.0" in parentheses in Critical Thinking questions correlates to the chapter objectives.

In addition, you may:

- Use the **Guide's Garment Study Worksheets** for close study of any actual or depicted garment.
- Look up definitions of key costume terms and other relevant vocabulary in the **Glossary**.
- Strengthen your visual vocabulary by referring to the **Illustrated Fashion Garment Guide**.

The time period covered in studying the history of western costume is measured not in hundreds but in thousands of years. The study of how people dressed is connected to all aspects of the civilizations in which they lived. A text provides the informational foundation from which a course grows. Your instructor will provide guidance to any unique approaches to the study of historic costume your course will take. By providing a consistent approach to all of the chapters in this text, we hope we have provided a vehicle that enhances the journey you will take through time and place, making the contents accessible, memorable, and exciting.

Garment Study Worksheet for an Actual Item of Historic Dress

Source of garment (museum/collection name) _____

Garment identification number _____

Worn by _____Woman _____Man _____Child

Approximate date of the item _____

Describe the garment using, when possible, terminology that would have been used at the time the item was worn.

Describe the silhouette and details of the shape as you see them before you.

Describe any evidence of alterations or repairs.

Consider the type of undergarments worn with this artifact. How was the shape enhanced or supported?

What sort of accessories might have been worn with this garment?

Establish a date range of no more than 10 years for the garment. Justify this time span.

What additional source material could you use to verify the date range?

Which of the themes discussed in your textbook can you relate this garment to?

What questions do you have about the garment or period after viewing this object?

Garment Study Worksheet for a Depicted Item of Historic Dress

Source of illustration _____

Item depicted _____

Worn by _____ Woman _____ Man _____ Child

Approximate date of the item _____

Civilization, culture, or period when worn _____

Primary medium _____ sculpture _____ painting _____ drawing
_____ photograph _____ other

Describe the item depicted using, when possible, terminology that would have been used at the time the item was worn.

List one other item, such as an accessory, undergarment, and so on, that might have been worn along with this garment.

If you were able to examine an actual garment, what could you learn that you cannot learn from the depiction?

If this is a garment that might have been worn in the late 19th or early 21st century, what is the name of a designer who might have been designing at this time?

Can you relate this item to any themes discussed in your textbook?

Introduction

As you read Chapter 1, make notes related to the areas identified below. These notes will help you understand how dress has been used by people throughout history.

1. According to the textbook, why do people wear clothes? (pp. 2–3)

2. What are the limits to the design of clothes? (pp. 3–4)

3. Explain (in your own words) what *theme* means as it is being used in the book. (p. 4)

4. List five themes presented in Chapter 1 and give examples from current fashion. (pp. 4–9)

 1.

 2.

 3.

 4.

 5.

5. How does this book define *fashion*? (p. 9)

6. If you were researching historic costume, list five kinds of sources you could consult. (pp. 10–11)

 1.

 2.

 3.

 4.

 5.

The Ancient World, 3000 BCE–300 CE

OVERVIEW

The roots of western civilization are found in the area around the Mediterranean Sea, a region that gave rise to a series of civilizations that formed the artistic, religious, philosophical, and political basis of western culture. The valley of the Nile River and the land between the Tigris and the Euphrates rivers were the locations of some of the earliest agriculturally based urban societies. The civilizations covered in Part One include Mesopotamia, Egypt, Crete and Greece, and Etruria and Rome. Although each of the Mediterranean cultures had its own distinctive forms of various items of dress, a number of basic garment types can be identified that were common to most of these cultures, such as the loincloth. The Mediterranean basin possesses a warm climate in which draped clothing such as shawls and cloaks are more comfortable than fitted clothing. With a few notable exceptions, garments here consisted of a draped length of square, rectangular, or semicircular fabric.

After completing the study of chapters in Part One, answer the following questions.

IMAGE-BASED QUESTIONS

1. Next to the image, write down the civilization it represents—Egypt, Greece, or Rome.

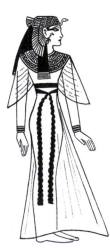
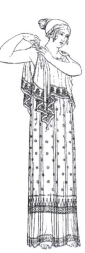
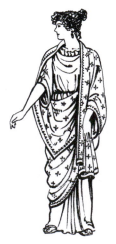

2. What aspects of this image are inspired by Greek dress? Which aspects anticipate Roman costume?

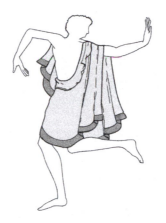

3. Compare and contrast the last two figures in Question 1.

QUESTION FOR REFLECTION

Chapter 3 describes how the various forms of the chiton illustrate changes in social values, and Chapter 4 describes the Roman use of costume to delineate social roles. Describe how costume was used to define social roles in ancient times. How do you use dress to show your role in society?

The Ancient Middle East, c. 3500–600 BCE

CHAPTER OBJECTIVES

After studying this chapter, you will be able to:

2.1 Describe the location of the civilizations of Mesopotamia and Egypt, and identify geographic factors related to dress.

2.2 Identify textile materials and relate textile characteristics to their use in garments from Mesopotamia and Egypt.

2.3 Name, compare, and contrast the cut and design of the major outer garments for Egyptian men and women.

2.4 Identify aspects of ancient Middle Eastern dress about which information is lacking.

2.5 Relate primary sources to one or more themes relating to ancient Middle Eastern dress.

KEY COSTUME TERMS

amulet	fillet	scarab
bead-net dress	kalasiris/calasiris	schenti/shent/skent/schent
chignon	kaunakes	tarbush
corselet	lock of Horus/lock of youth	tunic
diadem	nemes headdress	uraeus
eye of Horus	pectorals	wax cone
fez	red crown of Lower Egypt	white crown of Upper Egypt

HISTORIC SNAPSHOT

Founded by a people called the Sumerians, the first civilizations in the Middle East were located in Mesopotamia, in the area of present-day Iraq. The Sumerian civilization (3500–2500 BCE) never developed a strong political organization, and its loose confederation of states was conquered by the Amorites, who established a new empire with the capital at Babylon. Following a period of expansion, Babylonian power began to decline, and the Assyrians became the preeminent military force in the region until they were displaced by the Chaldeans in 612 BCE. Chaldean Babylon, notable for its luxury and wealth, was the site of the Hanging Gardens.

At the same time that the first Sumerian cities were built, the Nile River became the site of Egyptian civilization. The ancient Egyptian kingdoms flourished from about 3200 BCE until about 300 BCE, when Greeks led by Alexander the Great conquered Egypt. As a result of lasting monuments and elaborate writing systems, details of the life and history of Egypt are more complete than those of Mesopotamia over the same period.

SUMMARY OF THEMES

POLITICS	• Mesopotamians undergo frequent costume changes owing to their lands' easy access to invaders and traders. • Egyptian costume rarely changes owing to geographic isolation. • Egyptians may have adopted the tunic after the invasion of the Hyksos.
ECONOMICS	Patterns of trade bring more frequent changes to Mesopotamian costume compared to the stability of costume in Egypt. Mesopotamians trade with the Indus Valley civilizations of the Indian subcontinent, particularly gemstones and cotton.
CROSS-CULTURAL INFLUENCES	In Mesopotamia especially, cross-cultural contacts result from warfare and trade. A basic garment, the tunic, may have come to Mesopotamia through contacts with nearby mountain people.
SOCIETY	Upper classes and lower classes wear apparel different in both quality and variety, including headdresses that designate status.
TECHNOLOGY	• Linen, a fabric that is comfortable in the heat of a tropical climate and that could be made into soft, sheer, drapable fabrics, is the primary material from which garments are made throughout the history of ancient Egypt. • Mesopotamian costume relies primarily on wool. In later periods, both cotton and linen seem also to have been added to the materials from which Mesopotamians made their clothes.
ARTS	• Egyptians favor clarity of form in life and art, and so prefer clothing that complements the natural lines of the body. Egyptian costume began with the simple loincloth or skirt for men and a straight, close-fitting wrapped dress (sheath) or a skirt for women. • Babylonians' love of pomp and luxury is reflected in the heavy fabrics, rich patterns, and elaborate fringes of Mesopotamian styles. The early kaunakes skins and full-length garments, the draped styles of the later Babylonians, and the shawls that wrapped the Assyrian kings covered and obscured the body with layers of fabric.
RELIGION	Mesopotamian religions show a preoccupation with ethical problems, and moral reasons, possibly expressed as modesty in dress, may have influenced styles.

Circle or write in your answers as needed.

Look carefully at the images, then answer the questions that follow.

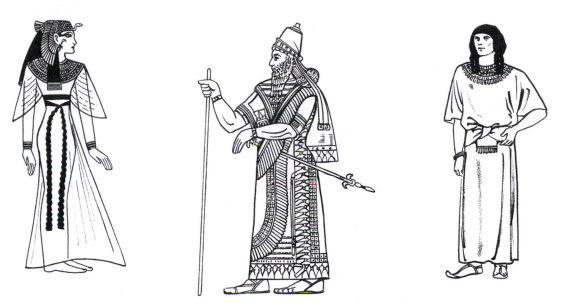

2.A 2.B 2.C

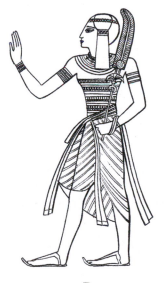

2.D

2.E

1. Which of these figures are wearing items of dress that display status? If an item displaying status is worn by the figure, write the name of that item in the blank and identify the status it shows (e.g., "headdress shows wealth").

Figure 2.A _____

Figure 2.B _____

Figure 2.C _____

Figure 2.D _____

Figure 2.E _____

2. Which of these textiles was most likely to be used for the garment depicted in each drawing? Write your choice beside the figure below.

 a. cotton

 b. wool

 c. silk

 d. linen

 e. none of the above

Figure 2.A _____

Figure 2.B _____

Figure 2.C _____

Figure 2.D _____

Figure 2.E _____

3. Do any of these garments appear to have come into either Egyptian or Mesopotamian dress as a result of contact with other cultures or trade? Write down the figure number, and after it explain where the garment originated and where it travelled.

4. Figure 2.E is a garment inspired by the dress of Mesopotamian women.

 true

 false

5. Figure 2.B represents traditional dress passed to the Assyrians by the Babylonians.

 true

 false

6. The garment in Figure 2.C may have originated with mountain people.

 true

 false

VISUAL OR PRIMARY SOURCE ANALYSIS EXERCISES

1. Find Figure 2.15 (Model of a Girl Bearing a Basket) in your textbook. If you were able to examine the actual garment, what could you learn that you cannot learn from the depiction?

2. Examine the artifact in the Global Connection in Chapter 2. How does it relate to cross-cultural influences?

3. Compare and contrast the cut and design of outer garments worn in Figure 2.9b (Mesopotamia) and Figure 2.17c (Egypt).

4. Working-class individuals are depicted for Mesopotamia in Figure 2.6 and for Egypt in Figure 2.12. What similarities and differences can you see in the dress for work being done in these illustrations?

5. Study Figures 2.6 (Mesopotamia) and 2.12 (Egypt) for clues about the kinds of textiles that were widely used in each of these civilizations. List the clues.

1. How did the geographic location of Mesopotamia and of Egypt influence the dress of each civilization? (CO 2.1)

2. Compare and contrast the textiles that were most important in Mesopotamia and Egypt. How do the differences in those textiles affect the predominant styles in each culture? (CO 2.2)

3. How did the cut and design of outer garments worn in Mesopotamia and Egypt differ, and what were the reasons for these differences? (CO 2.3)

4. Explain how lack of information about dress prevents us from having a complete understanding of dress in Mesopotamia and in Egypt, and give an example from each region to illustrate your explanation. (CO 2.4)

5. Explain how quotes from Mesopotamian letters and from contemporary comments by Herodotus on page 38 of your textbook aid in understanding the dress of these cultures. Identify themes that relate to these quotes. (CO 2.5)

6. How can contemporary comments from Mesopotamia and travellers to Egypt teach us about dress in these periods? Give one example of something learned about dress from contemporary comments in each of these cultures. (CO 2.5)

Crete and Greece, c. 2900–100 BCE

CHAPTER OBJECTIVES

After studying this chapter, you will be able to:

3.1 Analyze the difficulties in obtaining complete, accurate information about the dress of Minoans, Mycenaeans, and Ancient Greeks.

3.2 Compare textiles and their ornamentation in the Minoan and Ancient Greek civilizations.

3.3 Compare and contrast the dress of Minoan and Ancient Greek men and women.

3.4 Relate the dress of Ancient Greeks to social and family life in this period.

3.5 Explain how and why Ancient Greek styles have continued to influence dress in later periods.

KEY COSTUME TERMS

anakalypteria	chlanis tunic	himation
chiton (Doric, Ionic, or Hellenistic)	cuirass	perizoma
	diplax	petasos
chlaina	Doric peplos	Phrygian bonnet
chlamydon	greaves	pilos
chlamys	Hercules knot	stephane

HISTORIC SNAPSHOT

Minoan civilization flourished c. 2100–1100 BCE. During the Middle Period of Minoan civilization, 2100–1600 BCE, the Minoans maintained political control over what are today Crete and mainland Greece. The mainland people, called Mycenaeans, gradually grew stronger and by 1400 BCE dominated the region. At the beginning of the 13th century, after a series of devastating attacks by invaders, Mycenaean civilization disappeared, and Greece entered a Dark Age about which little is known. As the Dark Age ended, Greece entered a so-called Archaic Period, c. 650–80 BCE. Independent city-states developed, and in the Classical Age (c. 500–323 BCE) Greece enjoyed one of the most creative eras in the history of civilization. Greece established colonies and spread its influence throughout the Mediterranean world. As Greek influence waned after c. 300 BCE, the Romans supplanted the Greeks as the dominant force in the area.

SUMMARY OF THEMES

POLITICS	• Minoan political control of Mycenae helps to spread Minoan-influenced styles to mainland Greece. • The conquest of the Minoans and the Mycenaeans by outside forces around the end of the 11th century BCE closes off information about these peoples.
ECONOMICS	The export of textiles and import of dyestuffs to and from other Mediterranean countries contributes to the development of Minoan styles. Trade may have influenced some specific garments, such as shoes and sheep fleece skirts.
CROSS-CULTURAL INFLUENCES	The Ionic chiton is most probably a Middle Eastern style adopted by Greeks in Ionia, a settlement at the far eastern end of the Mediterranean. From Ionia the style spreads to the mainland, where it supplants the Doric peplos.
SOCIETY	• About 480 BCE, as a result of war with Persia, Greek men reject the Ionic chiton in favor of a new style, the Doric chiton, which represents a sort of revival of the older, native Doric peplos. The simpler Doric chiton is more compatible with the social value of equality than the more elaborate Ionic chiton. • The shape and construction of costume for men and for women in Greece is not markedly different, but gender roles appear in the dress of brides and in the veiling of married women.
TECHNOLOGY	Minoan weaving and dyeing skills, especially of wool fibers, make possible a wide variety of highly ornamented fabrics used in dress.
ARTS	Greek architecture and dress correspond. Tall, slender Doric and Ionic building columns with fluted surfaces reflect long, pleated, tubular chitons. Decorative motifs often appear both on buildings and as ornamentation on garments.

Circle or write in your answers as needed.

Look carefully at the images, then answer the questions that follow.

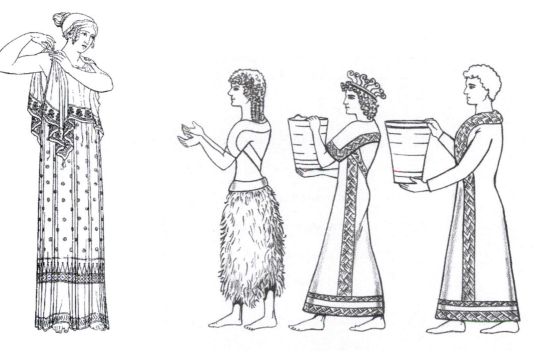

3.A 3.B

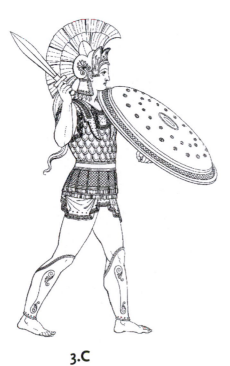

3.C

3.D

1. What is the name of the garment shown in Figure 3.A?

 a. Doric peplos

 b. Ionic chiton

 c. Doric chiton

 d. exomis

2. Figure 3.A was used in the _____ period and was made of either _____ or _____ fiber.

3. The garments worn in Figure 3.B provide evidence that:

 a. Minoan costume was tailored and was not draped.

 b. Minoan men and women both wore skirts.

 c. Cretans wore skirts similar to the sheepskin skirts of Mesopotamia.

 d. All of the above.

4. The individual wearing the garment in Figure 3.C represents the Dark Age of Greece.

 true

 false

5. Figure 3.C depicts a soldier. Label each of the following pieces of equipment on the drawing:

 cuirass

 helmet

 cheek guards

 greaves

6. The individual depicted in Figure 3.D may have been a goddess or priestess.

 true

 false

7. The apron-like garment in Figure 3.D may have been derived from a primitive loincloth.

 true

 false

8. All Minoan women's bodices exposed their breasts.

 true

 false

VISUAL OR PRIMARY SOURCE ANALYSIS EXERCISES

1. You have been asked to construct a costume for your friend, who is going to a costume party, and you decide to make an Ancient Greek costume for her. Study the way the garment in Figure 3.A is constructed, then:

 a. Make a list of the supplies you would need to create this costume.

 b. Explain how each of the supplies will be used.

2. Look closely at the three types of skirts depicted for Minoan women's dresses in Figures 3.4, 3.5, and 3.6 in your textbook. Compare their appearances and evaluate the conclusions scholars have reached about how each skirt was constructed. Agree or disagree with these conclusions, but give your reasons for that opinion.

3. Study Figure 3.2 and answer these questions.

 a. What event is depicted in this scene?

 b. Identify all the items of dress depicted here.

 c. Identify any protective clothing and explain its function.

4. Look at the Modern Influences feature in Chapter 3. Answer the following questions.

 a. What aspects of this illustration are most closely connected to dress worn in the Greek period? Are there other types of 21st-century dress that might use similar features? If so, what, and which features would lend themselves to a modern type of dress?

 b. Identify two additional aspects of Greek dress other than clothing that are similar to 21st-century items or practices. What are they and how might they be used today?

1. Relate the dress of Minoan, Mycenaean, and Ancient Greek civilizations to some specific historical event, explaining what impact the event had on changes in dress of that period. (CO 3.1)

2. Evaluate the major sources of information about Greek costume in the Archaic, Classical, and Hellenistic periods. How were costume historians misled about the Greek use of color? (CO 3.1)

3. How did Minoan weavers ornament their textiles? Compare what is known about Minoan ornamentation techniques to those adopted by the Mycenaeans or by the Greeks of the Archaic period. (CO 3.2)

4. How did the dress of Minoan men and women contrast with the dress of Ancient Greek men and women? (CO 3.3)

5. How did social and family life influence the customary dress of women and men in Ancient Greece? Why would it be difficult to answer this question about Minoan social and family life? (CO 3.4)

6. Why did Greek styles continue to influence dress in subsequent periods? Describe some examples of those influences. (CO 3.5)

Etruria and Rome, c. 800 BCE–400 CE

CHAPTER OBJECTIVES

After studying this chapter, you will be able to:

4.1 Identify an Etruscan contribution to Roman dress.
4.2 Describe textile production, processing, and care.
4.3 Describe the layers of dress worn by Roman citizens and their wives.
4.4 Analyze the role of status symbols in Roman dress of men, women, and children.
4.5 Compare the sources of information about dress for Etruscans and Romans available to scholars.

KEY COSTUME TERMS

balteus	pallium	subligar (for men)/subligaria
birrus/burrus	sagum	(for women)
clavus	sandalis	tebenna
gynaeceum	sinus	toga (candida, praetexta, or
indutus	soccus	virilis)
instita	solae	tutulus
lacerna	stola	umbo
paenula	strophium	vitta
palla		

HISTORIC SNAPSHOT

The Etruscan culture that developed along the Italian peninsula by about 800 BCE was superior in skills and artistic production to neighboring tribes. Gradually, a confederation of Etruscan city-states gained control of large areas. Greek colonies were established in Sicily and in some locations on the Italian peninsula. A local tribe that later took the name "Romans" steadily grew stronger, and by about the 3rd century BCE had subjugated the Etruscans.

Kings ruled Rome until the formation of a republic in 509 BCE. Under the Republic, Rome gained control of all of Italy; much of North Africa; and large parts of the Middle East, Eastern Europe, and continental Europe. Augustus, the successor to the assassinated Julius Caesar, established the Roman Empire in 27 BCE, adding more territory. After 200 years of prosperity and relative peace, the Empire began to decline after the 3rd century CE. The capital was moved east to Constantinople in 325 CE. An emperor for the Eastern or Byzantine Empire was named in 395 CE and another for Rome, and by 476 CE the Roman emperor was deposed by barbarians, thus ending the Roman Empire, while the Byzantine Empire flourished.

SUMMARY OF THEMES

POLITICS	The Roman Empire expands through warfare. Leaders such as Julius Caesar and later emperors conquer the territory controlled by Rome, thereby bringing dress influences and products to Rome from all parts of the empire.
ECONOMICS	Roman textile production eventually takes on an almost factory-like production, using female slaves as workers. Trade goods from around the empire make their way to markets in Rome.
CROSS-CULTURAL INFLUENCES	Romans wear silk, obtained through trade with China, as a luxury textile afforded only by the most affluent and powerful.
SOCIETY	• Etruscan women enjoy unusually high status. • Only adult Roman male citizens wear togas.
TECHNOLOGY	Romans make advances in the production of fibers, the manufacture of yarns, and fulling and bleaching of cloth to clean and maintain togas.
ARTS	Wall paintings and mosaics are among the most useful sources of evidence about Roman dress. Sculptures depicting important Roman political figures and their wives give clues about fashion changes in hairdressing and beards.
RELIGION	Roman men carrying out religious rites pull their togas over their heads, creating a hoodlike effect.

Circle or write in your answers as needed.

Look carefully at the images, then answer the questions that follow.

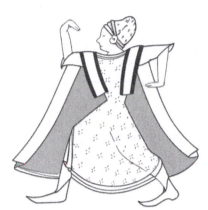
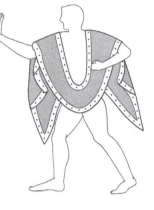
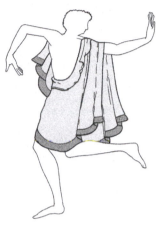

4.A

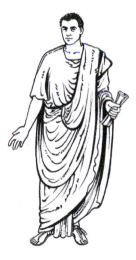

4.B

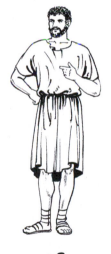

4.C

4.D

1. Which figures are Etruscan? _____

2. Which figures are Roman? _____

3. What is the gender of each of the figures in Figure 4.A?

 left _____

 center _____

 right _____

4. Label each of the following features on the relevant drawing(s):

 Etruscan mantle

 pala

 sinus

 stola

 tebenna

 toga

 tutulus

 umbo

5. Indicate the status you think each person has and explain the clue you followed:

 Figure 4.A (left) _____

 Figure 4.B _____

 Figure 4.C _____

 Figure 4.D _____

6. What is the name of the garment an affluent man would wear to a dinner party? Describe this type of dress.

7. From what type of textile would the fabric in the garment shown in Figure 4.D have been made? Give reasons for your choice.

8. What feature of present-day dress is sometimes described as "toga influence"?

VISUAL OR PRIMARY SOURCE ANALYSIS EXERCISES

1. Look closely at Figures 4.11 and 4.12 in your textbook to answer the following questions.

 a. When you compare the early toga and the imperial toga in Figure 4.11, what differences do you see in the shape?

 b. What features of the imperial toga does the shape change make possible? Give the names and explain the purpose of each feature.

 c. If a man were a political candidate, how would his toga differ from that of other men?

 d. What would you add to the drawing of the imperial toga if it were intended to be a toga praetexta for a boy 12 years of age?

2. Look closely at Figure 4.17.

 a. Where can you find the feature that some researchers believe is what makes a sleeveless outer tunic into a status symbol identifying the woman as an upper-class Roman matron?

 b. What was that garment called?

3. Look at Figure 4.15 in your textbook. The caption for this illustration is relatively brief. Expand that caption so that someone who is only looking at this illustration and has not read the main text can understand what he or she is seeing.

CRITICAL THINKING QUESTIONS

1. Explain the meaning of this statement as it applies to Etruscan and Roman dress: "Etruscan dress made an important contribution to Roman dress through dress required for Roman citizens." (CO 4.1)

2. Trace the journey a Roman toga would have taken from the time its fiber was obtained until the man wearing it picked it up after it was cleaned. (CO 4.2)

3. Relate differences in the costume of Greek, Etruscan, and Roman men and women to the treatment of women in those societies. (CO 4.3)

4. How does the advice the Roman poet Ovid gives to men differ from that he gives to women? (see page 87)

5. Give examples to illustrate this statement: "Roman dress often communicates the status of the wearer."

6. Evaluate the sources that would be available if you wanted to do research about Etruscan and Roman dress, concluding with a summary of sources that would be most useful and identification of aspects of sources that would present limitations. (CO 4.5)

7. Pay attention to what people are wearing on campus, on the street, and in the media. What influences from Roman dress can you find?

The Middle Ages, 300–1500

OVERVIEW

In 330, Emperor Constantine moved the capital of the Roman Empire to Byzantium, renamed Constantinople, signaling the decline of Rome and the western portion of the empire. It also meant two cultures would develop in the empire, in addition to two lines of emperors. The wealthier, more populous eastern empire was well situated to defend itself and dominate trade routes. The western empire, ruled from Rome, was overwhelmed by the mass migration of German tribes, which began at the close of the fourth century and continued throughout the fifth century. By the 1400s the arts, the intellectual life, and the social structure of Europe had been virtually transformed. Some historians and social scientists believe that the phenomenon of fashion in dress in western society began in, or at least accelerated during, the Middle Ages. The wealthier classes initiated sumptuary laws to discourage middle- and lower-class consumption of similar attire.

After completing the study of chapters in Part Two, answer the following questions.

IMAGE-BASED QUESTIONS

1. What are the similarities and differences between the following two figures?

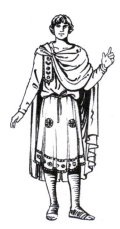 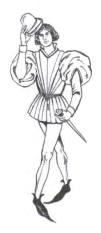

2. How is the idea of conspicuous leisure present in both of these images?

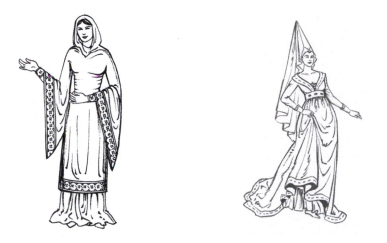

3. Next to the image, write down if it shows a bell or batwing sleeve.

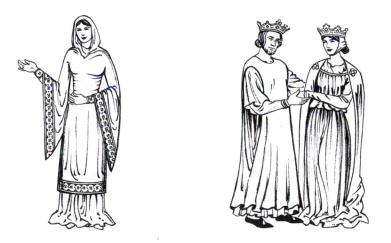

QUESTION FOR REFLECTION

Describe how cross-cultural influences affected fashion during the Middle Ages. How does fashion information spread today? How is that spread of information similar to and different from that during the Middle Ages?

CHAPTER FIVE

The Early Middle Ages, c. 330–1500

CHAPTER OBJECTIVES

After studying this chapter, you will be able to:

5.1 Explain cross-cultural influences in Byzantine dress.

5.2 Describe the new technologies and ideas that the Crusades brought to Europe.

5.3 Show how dress communicated social class during the early Middle Ages.

5.4 Describe or create a garment suitable for 21st-century use applying early medieval styles.

KEY COSTUME TERMS

barbette	dalmatic	mantle (closed, open, double,
bliaut	gaiters	or winter)
bliaut gironé	gardcors/gardecorps	pallium
braies	garnache	paludamentum
chainse	gores	roundels
chemise	hauberk/byrnie	segmentae
circlets	heraldic device	surcote
clogs	herigaut	tabard
coif	hose	tablion
cornette/liripipe	leg bandage	tonsure
cote	magyar sleeve	
cowl	mail	

HISTORIC SNAPSHOT

The Byzantine Empire (330–1453) had as its capital Constantinople, a Greek city located at the entrance of the Black Sea. As a result of its command of major trade routes between western Europe and Central Asia, Russia, and East Asia, Constantinople was the metropolis of the Mediterranean economy. By the 6th century the Empire controlled large areas around the Mediterranean. Throughout its history Byzantium was at war with a series of enemies, including crusaders who sacked the city and displaced the emperor in 1204. In 1261, a Byzantine emperor retook Constantinople, but the once-great Empire had vanished. Finally, in 1453, the Ottoman Turks captured the capital, destroying the Empire.

During the same time period (300–1300) in western Europe, the Roman Empire disintegrated. For centuries, Germanic tribes had been filtering into the Roman Empire in search of land. In some cases they intermarried with Romans, converted to Christianity, and established German kingdoms. After the fall of the Roman Empire, the most notable of these were the Merovingian Dynasty and the Carolingian Dynasty. A leader of the latter, Charlemagne (768–814), conquered Italy and was crowned emperor of the Romans, but his successes were not enough to unite the eastern and western sections of Europe, which had developed along separate lines since the end of the Roman Empire. Eventually, Carolingian rule collapsed under the impact of successive invasions, making way for feudal monarchies, the nations of the future.

In the 10th to the 13th centuries in Europe a form of government developed in which local rulers could call on their dependents for support in battles, known as the *feudal system*. Rulers in different regions had different titles and differing degrees of authority. When the Muslims gained control over the holy places of Christendom, the Catholic Church called upon the western nations to summon their warriors to a crusade (1095) to regain control of the holy places. The last crusade ended in 1272.

SUMMARY OF THEMES

SOCIETY	• In the 10th to the 13th centuries, lower-class men wear short tunics and upper-class men wear long tunics. These more encumbering garments, in which it would be difficult to do menial work, demonstrate conspicuous leisure. With their voluminous sleeves, women's garments of the 12th century are even more restrictive. • Societal changes allow for the first inklings of the concept of fashion or rapid style changes. Sumptuary laws are established to prevent adoption of certain fabrics, garments, and styles by the lower classes.
POLITICS	• Crusaders bring back new textiles and garments from the Middle East. • The Moors conquer and occupy Sicily and Spain, spreading new technologies important for dress. • As a result of political conflict and warfare, civilians adopt new garments associated with armor.
CROSS-CULTURAL INFLUENCES	• Byzantine dress blends Eastern and Roman styles. Byzantine decorative elements in dress travel west to influence the dress of the rich and powerful Merovingian and Carolingian kings and their courts. • Roman and barbarian styles merge in the dress of the common people. • Cross-cultural themes play a dominant role in the history of dress in western Europe from the Early Medieval Period onward.
TECHNOLOGY	Moorish conquerors introduce the cultivation and processing of silk fibers (sericulture) and cotton fibers using the spinning wheel.
ARTS	Brightly colored embroideries and jeweled ornamentation echo the jewel-like, brightly colored mosaics that decorate Byzantine churches.

Circle or write in your answers as needed.

1. Beginning with the layer closest to the body and ending with the outermost garment, describe the garments that men and women wore in the 10th and 11th centuries. Use the Key Costume Terms as a starting point. List the functions of each garment.

2. Beginning with the layer closest to the body and ending with the outermost garment, describe the garments that men and women wore in the 12th and 13th centuries. Use the Key Costume Terms as a starting point. List the functions of each garment.

Look carefully at the images, then answer the questions that follow.

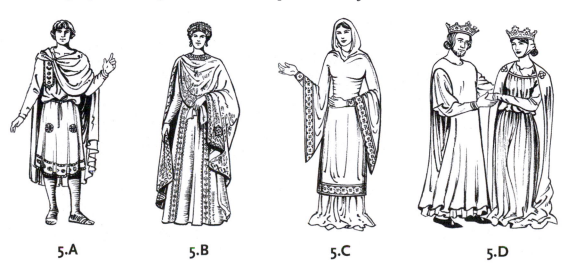

5.A 5.B 5.C 5.D

3. The circular medallions on Figure 5.A are called:

 a. roundels

 b. segmentae

 c. ornaments

 d. banding

 e. tablion

4. The garment the woman in Figure 5.B is wearing is called a:

 a. lorum

 b. paludamentum

 c. tunic

 d. tablion

 e. tonsure

5. The woman in Figure 5.C wears a:

 a. chemise

 b. bliaut gironé

 c. girdle

 d. mantle

 e. barbette

6. The man in Figure 5.D wears a sideless surcote. The woman in Figure 5.D wears a surcote with open mantle.

 true

 false

1. Using appropriate costume terminology, identify how Figure 5.C in the Review Exercises demonstrates the concepts of conspicuous consumption and conspicuous leisure.

2. Of the figures in the Review Exercises, which is from a later time period? What evidence supports your assertion?

3. Look up Figure 5.6 in your textbook. What elements of dress were influenced by Rome? What elements of dress were influenced by Asia?

4. Using correct costume terminology, create a new caption for Figure 5.15 in your textbook.

5. Figure 5.18 in your textbook shows tunics with gaitered hose, cloaks, and veils. Research (online or in print) present-day garments inspired by these features.

CRITICAL THINKING QUESTIONS

1. What costume components from the Byzantine Period reflect both Roman and Middle Eastern styles? How do these items show Roman influences? Middle Eastern influences? (CO 5.1)

2. Who could wear the paludamentum and the pallium or lorum during the Byzantine Period? What might these restrictions indicate about the role of the empress in the Byzantine political system? (CO 5.3)

3. When and how was silk culture introduced to the Byzantine Empire? How did the production of silk contribute to the influence of Byzantine style in western Europe? (CO 5.2)

4. What aspects of clerical garb appear to be derived from Roman dress? How and why did monastic dress differ from clerical dress? (CO 5.3)

5. How did the Crusades contribute to cross-cultural influence in costumes of the Early Middle Ages? (CO 5.2)

6. Sketch or describe three present-day garments that use these costume elements introduced in Chapter 5. How would you make the garments look fashionable for today? (CO 5.4)

 dolman or magyar sleeves

 cowl neckline

 hanging sleeves

 mantle (your choice open, closed, winter, or double)

 stole

CHAPTER SIX

The Late Middle Ages, c. 1300–1500

CHAPTER OBJECTIVES

After studying this chapter, you will be able to:

6.1 Identify items of dress by the names by which they were known during the Late Middle Ages.

6.2 Compare and contrast men's and women's garment styles of the Late Middle Ages.

6.3 Evaluate the kind and quality of sources scholars use to study dress in the Late Middle Ages.

6.4 Analyze how garments and the training of tailors during this period demonstrate the concept of fashion.

KEY COSTUME TERMS

benzant	gown	plastron
bowl crop	hennin	pourpoint
chaperon	houce/housse	"putting out" system
coat of plates	houppelande	revers
corset/round cape	houppelande à mi-jambe	set-in sleeve
cote-hardie	huke	sugar loaf
crackowe/poulaine	jacket	tippets
dagging	livery	
doublet/gipon	mi-parti/parti-colored	
frock	pattens	

HISTORIC SNAPSHOT

During the Late Middle Ages (1300–1500) in Europe, governments became more centralized, free peasants replaced serfs and paid rent to nobility, and cities and towns became an important source of tax revenue. The Black Death (plague) killed a third of Europe's population, making labor scarce, empowering the various guilds, and affording people of the lower classes the possibility of advancement. The growing merchant class was able to obtain and wear fashionable clothing, allowing for less-rigid class distinctions, and textiles became an important commodity available through trade. Courts were renowned for their luxury, extravagant costume, and lavish ceremony and entertainment.

SUMMARY OF THEMES

SOCIETY	• Women of the Late Middle Ages lose many of the economic and social privileges they had in the earlier Middle Ages, possibly owing to their increased life expectancy. • Greater distinctions emerge between dress for men and dress for women. By the second half of the 14th century, men adopt short styles, which, in contrast to the long, flowing gowns of women, dramatize the difference between active roles for men and passive ones for women. The nobility pass sumptuary laws to restrict luxurious dress in order to set themselves apart from the newly rich and lower classes; however, these laws are generally ignored.
ECONOMICS	• Increased trade brings greater prosperity. Fashionable clothing comes within the reach of an enlarging middle class, especially the merchant class. • Changes in the textile manufacturing processes lead to greater prosperity for the textile trades.
POLITICS	By the second half of the 14th century, military dress yields short styles for men: the pourpoint and hose.
CROSS-CULTURAL INFLUENCES	• Travel and diplomatic exchanges between Europeans and Ottomans bring Middle Eastern influences to the West; for instance, the turbanlike headdress becomes another way of wearing the chaperon hood. In the Late Middle Ages, women's "horned" headdresses, including hennins of various heights, resemble Ottoman headgear. • A wide variety of fabrics from all over the world comes to western European cities through increased trade. Members of the upper-class wear these fabrics in the form of colorful and elaborate garments.
TECHNOLOGY	• Innovations in textile manufacturing processes lead not only to greater prosperity for the textile trades but also to more variety in the raw materials of fashion. • Tailors gain skill in cutting and sewing more and more sophisticated garments.
FASHION	Style changes are increasingly rapid in the 14th and 15th centuries.

Circle or write in your answers as needed.

1. Medieval society was divided into three classes. What were they, and how did styles of dress differ from one class to another?

Look carefully at the images, then answer the questions that follow.

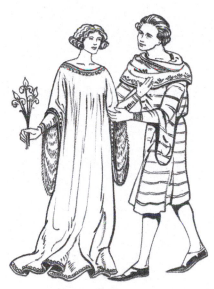

6.A

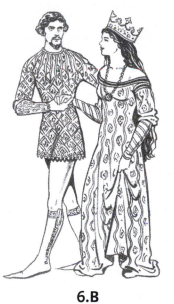

6.B

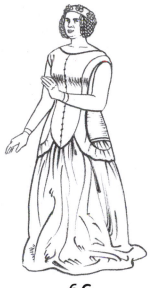

6.C

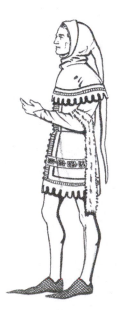

6.D

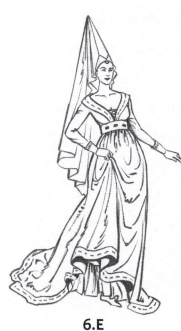

6.E

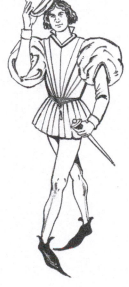

6.F

2. The woman in Figure 6.C is wearing a sideless surcote with plastron.

 true

 false

3. The hood the man in Figure 6.D is wearing would be called a:

 a. barbette with fret

 b. coif

 c. houppelande with dagging

 d. chaperon with liripipe

 e. chemise with braies

4. The type of shoes worn by the men in Figures 6.B and 6.D are called poulaines.

 true

 false

5. The man in Figure 6.B is wearing:

 a. houpelande with armor

 b. trunk hose with pourpoint

 c. cote-hardie with braies

 d. doublet with hose

 e. coat of plates with haubergeon

6. The hat worn by the man in Figure 6.F is called a:

 a. sugarloaf hat

 b. draped hood

 c. chaperon

 d. fillet

 e. coif

7. Match the figures with the correct date range.

Figure 6.A c. 1450–1500

Figure 6.B c. 1340–1400

Figure 6.E c. 1300–1340

VISUAL OR PRIMARY SOURCE ANALYSIS EXERCISES

1. Compare and contrast the male and female figures in Figures 6.A and 6.B. Which figure demonstrates greater gender distinction? How so?

2. How does the clothing of the woman in Figure 6.E and the man in Figure 6.F demonstrate the concept of fashion? Name the specific garment elements that demonstrate conspicuous consumption and conspicuous leisure.

3. Compare and contrast the woman depicted in Figure 6.4 with the woman drawn in the Global Connections image in your textbook. How are the headdresses similar? How are they different?

4. Describe each of the garments worn by the woman and men in Figure 6.5 from your textbook.

5. Sketch or describe at least five elements of dress as seen in Figure 6.24 that could be translated into fashionable styles today.

CRITICAL THINKING QUESTIONS

1. What are the major sources of information about costume in the 14th and 15th centuries? Why is more information available to the costume historian for these periods than for the earlier centuries of the Middle Ages? What are the strengths and weaknesses of the available information? (CO 6.3)

2. Carefully considering the changes in costume during the Late Middle Ages, explain the difference between the frequency of big modifications of silhouette and smaller details. What examples can you provide from the textbook that support your answer? Cite text and images. (CO 6.4)

3. Why do you think gender differences become more evident in the Late Middle Ages compared to the Early Middle Ages? (CO 6.2)

4. The names for items of costume are often related to their function, their appearance, or some other characteristic. List some items from the 14th and 15th centuries that have such names, and describe how they relate to function, appearance, or some other characteristic. (CO 6.1)

5. Thorstein Veblen, an economist, spoke of dress as a way of showing status through conspicuous consumption (i.e., wearing something that is obviously costly) and through conspicuous leisure (wearing something that shows that a person does not need to do hard work). What are some examples of clothing of the 14th and 15th centuries that would demonstrate conspicuous consumption? Conspicuous leisure? (CO 6.4)

The Renaissance, 1400–1600

OVERVIEW

Exciting cultural changes began in Italy around the mid-14th century, when sculptors, painters, and writers began to identify with the ancient civilizations of Greece and Rome. They believed that there had been a rebirth of classical arts and learning, or a Renaissance—a term derived from the Italian word *renascere*, meaning "to be reborn." Modern historians in general do not consider that there was a rebirth of the arts as such but rather that Europe underwent a chaotic change, a period of profound transition as medieval institutions crumbled and a new society and culture began to appear. The Renaissance was a time of transition from the medieval to a modern view of the world. The Renaissance began around the middle of the 14th century in Italy and lasted until the end of the 16th century.

After completing the study of chapters in Part Three, answer the following questions.

IMAGE-BASED QUESTIONS

1. Using the following figures, describe the different purposes undergarments served during the Renaissance.

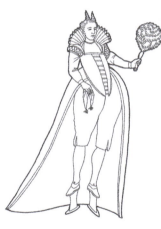

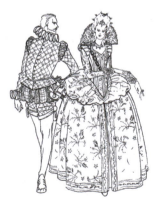

2. Describe the changes that occurred in menswear using the images below.

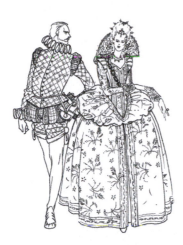 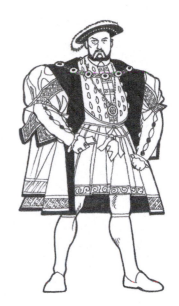

QUESTIONS FOR REFLECTION

1. Chapter 8 demonstrates the ways dress in 16th-century Europe showed increasing international flavor. Describe how specific forms of communication and technology enabled this cross-cultural influence.

2. The decorative arts and international influence were particularly important to Renaissance dress. What aspects of art impact fashion today? How do international influences impact designers and consumers in today's world?

The Italian Renaissance, c. 1400–1600

CHAPTER OBJECTIVES

After studying this chapter, you will be able to:

7.1 Define the term *Renaissance,* summarize the changes in the fine arts, and identify any effect these changes had on dress.

7.2 Identify developments in the economy and the manufacture of textiles and acquisition of clothing that contributed to changes in Italian dress.

7.3 Summarize the kind and quality of sources scholars use in the study of Italian Renaissance dress.

7.4 Compare the typical dress of working- and upper-class men and women during the Italian Renaissance.

7.5 Explain the adoption of foreign influences into Italian Renaissance dress in the 15th and the 16th centuries.

KEY COSTUME TERMS

beehive-shaped hat	ferroniere	Phrygian bonnet
ceremonial robe	guardaroba	puffs
chopines	gussets	slashes
codpiece	hose	
coif	lacing	

HISTORIC SNAPSHOT

The Renaissance (1400–1600), which takes its name from the rebirth of Classical arts and letters, bridges medieval times and the modern period. At the time of the Renaissance, the word *Italy* referred not to a country but to a geographic area made up of a number of small city-states ruled by princes. The population was roughly divided among the aristocracy, the merchant class, artisans and artists, town laborers, and the

peasants of the countryside. Although men of aristocratic families made up the ruling class in most cities, in some places ruling families came from a merchant background, and most large businesses were in some way related to the textile industry, weaving, dyeing, finishing, or trading cloth. Wool and silk were the primary fabrics used in Italy, and many of the fabrics of the day utilized patterns and decorative motifs that reflected close trading contacts between Italy and the Far East.

Renaissance patrons supported artists who are still considered among the greatest of Western Civilization, and their art provides an extensive record of the clothing worn during the Italian Renaissance.

SUMMARY OF THEMES

POLITICS	Conflicts between European countries and Italian city-states, and also among Italian city-states, bring style ideas to Italy and take Italian styles to other European lands.
ECONOMICS	• Trade with the Middle East facilitates the exchange of textile designs. • An active Italian textile industry makes the manufacturers wealthy, stimulates the economy, and enables the consumption of fashionable clothing of great beauty.
CROSS-CULTURAL INFLUENCES	European women and men don turban-like headwear as a result of Middle Eastern contacts.
TECHNOLOGY	Italian manufacturers learn to yield complex designs in textiles, providing beautiful materials for the dress of Italians.
ARTS	Artists paint realistic portraits showing both elaborate, upper-class garments and also scenes of every day life that make it possible to observe the dress of various social classes. Their output is an outstanding resource for the study of costume history.
RELIGION	Churches and other religious institutions stimulate the painting of scenes to tell biblical stories. Artists usually depict individuals in Renaissance dress, although some characters, such as the Madonna and some saints, are sometimes shown in traditional styles from the past.

Circle or write in your answers as needed.

Look carefully at the images, then answer the questions that follow.

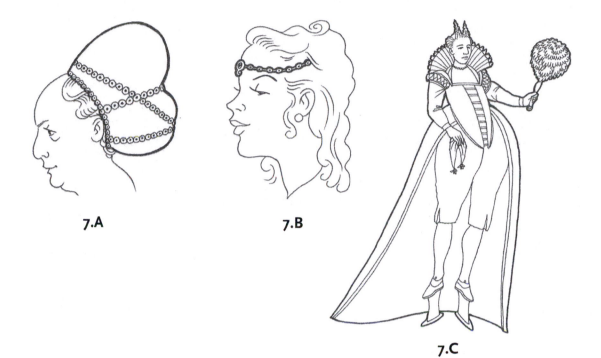

7.A 7.B

7.C

1. Which figure shows a ferroniere?

2. The ferroniere would have been worn by either a man or a woman.

 true

 false

3. What does Figure 7.C depict? List the names of all features you can identify.

4. In which Italian city were the items in Figure 7.C worn?

5. What is the name of the footwear depicted in Figure 7.C and what were its characteristics?

6. During which period would Figure 7.C have been worn?

 a. 1700–1750

 b. 1440–1500

 c. 1500–1550

 d. 1400–1450

 e. none of the above

7. Renaissance styles were often ornamented with puffs and slashes.

 true

 false

VISUAL OR PRIMARY SOURCE ANALYSIS EXERCISES

1. Examine the figures in the Review Exercises. Which figures show evidence of influences from outside of Italy? What is that influence and where did it originate?

2. Look up Figure 7.5 in your textbook, then answer the following questions about the bowman in the painting.

 a. What is the green upper body garment he is wearing called?

 b. What is the type of sleeve on the green garment?

 c. Describe two other types of sleeves used on men's garments.

 d. What is the name applied to the color of his hose and in which earlier period did this style appear?

 e. Based on the appearance of his hose, do you think they were woven or knitted? Give the reasons for your choice.

3. Look up Figure 7.14 in your textbook. Imagine that this illustration showed only the mother at lower right and the two children. Rewrite the caption for these three figures describing their dress.

4. Look closely at Figure 7.12 and Contemporary Comments 7.2. Which of the items of dress mentioned in the Contemporary Comments can you find in Figure 7.12? What additional features do you think are typical of women's dress of the Italian Renaissance?

1. Why do scholars call this period the Renaissance? Explain how developments in the thinking and arts of this period justify this name. (CO 7.1)

2. How did the business interests of local merchants influence Italian Renaissance costumes, especially in cities like Florence? (CO 7.2)

3. Contrast the ways in which upper-class Italian Renaissance men and women dressed and obtained their clothing with the ways in which working-class and poor Renaissance men and women did. (CO 7.4)

4. Assess the strengths and weaknesses of the sources available for the study of Italian Renaissance dress. (CO 7.3)

5. How did foreign elements influence Italian costume in the 16th century? Explain why some specific foreign influences came to dominate. (CO 7.5)

6. Compare costume in Italy and costume in Northern Europe in the second half of the 15th century. Describe a few similarities and differences in those same areas in the 16th century. (CO 7.5)

CHAPTER EIGHT

The Northern Renaissance, c. 1500–1600

CHAPTER OBJECTIVES

After studying this chapter, you will be able to:

8.1 Identify items of dress by their Northern Renaissance names.

8.2 Connect political leaders from this period to popular fashions at the time.

8.3 Assess the impact of religious strife on dress.

8.4 Relate the structure of undergarments of this period to the silhouettes of men's and women's dress.

8.5 Relate the themes of technology and cross-cultural contacts to changes in what was worn during the Northern Renaissance.

KEY COSTUME TERMS

aiguillettes	gallygaskins	Spanish farthingale
bombast	latchets	stays
bum roll	nether stocks	stomacher
busk	open breeches	supportasse
canions	pair of bodys	trunk hose
capotain	paltock	underpropper
codpiece	peascod belly	Venetians
conch (French: *conque*)	pecadils	verdugale (Spanish farthingale)
culots	petticoat	wheel, drum, or French farthingale
duckbills	pomander	
French bonnet	ruff	
gabled	slops	

HISTORIC SNAPSHOT

The spirit of the Renaissance in the arts and in philosophy gradually moved to northern Europe. Along with changes in arts and letters came changes in religious attitudes, which culminated in the Protestant Reformation. This revolution against the Roman Catholic Church started in the German states and spread throughout the German Holy Roman Empire, which included the Hapsburg Territories, the Low Countries, and Spain—all of which came under the control of one man, Emperor Charles V.

Spain dominated Europe throughout the early part of the century because of Charles V's political interests and the wealth acquired through trade in goods from the Americas. When Charles V abdicated the throne and divided the Empire between his son and his brother, the Holy Roman Empire was effectively ended (although it nominally existed until 1806) and Spain's political influence gradually began to wane.

Religious tensions were common across Europe. In England, Henry VIII split with the Church of Rome over its refusal to let him divorce his Spanish queen, Katharine of Aragon, and established a national Church of England. After a brief return to the Roman Church, Henry's daughter, Elizabeth, resolved the direction of the Church of England and instituted the basis for the standard of English Protestantism. In France, Protestant Bourbon Henry IV converted to Roman Catholicism and soothed religious problems by issuing the Edict of Nantes, guaranteeing rights to all Protestants.

Throughout this period, increased travel and printed books brought greater cross-cultural influences to dress in Europe, and wealth from trade and conquests made courts a center for the display of changing fashions.

SUMMARY OF THEMES

POLITICS	Alliances are formed through royal marriages. Foreign brides often bring with them new fashions from their homeland that are then adopted in their husbands' homelands. For instance, Katharine of Aragon brought from Spain to England the verdugale, which evolved into the farthingale.
ECONOMICS	The invention of a knitting machine for stockings by William Lee in England was refused a patent by Queen Elizabeth I because she thought it would put handknitters out of business. Lee took the invention to France, where it was accepted.
CROSS-CULTURAL INFLUENCES	Trade with East Asia is especially active. Individual garments such as the Spanish ropa are thought to have come from the Middle East. Trade brings influences from around the world.
SOCIETY	Spanish society imposes firm restraints on behavior with skirts that cover the feet and stiff, rigid styles. Conservative tendencies are reflected in the dress of some other societies as well.
TECHNOLOGY	• Lace-making technology adds this decorative textile to the options available for ornamenting dress. • The printing of books makes it possible to circulate information and illustrations about dress throughout Europe and its colonies.
ARTS	• Portraits depicting monarchs and leading figures of the era serve costume historians well as a source of information about dress of the period. • Literature flourishes, with contributions from figures such as Shakespeare.
RELIGION	The Protestant Reformation contributes to political upheavals throughout Europe. Some Puritan groups in England find fashions to be sinful and urge men and women to abandon new fashions such as starched ruffs.

Circle or write in your answers as needed.

Look carefully at the images, then answer the questions that follow.

8.A

8.B

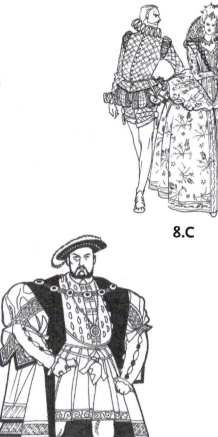

8.C

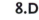

8.D

8.E

1. What garment type is depicted in Figures 8.A and 8.B?

2. Which are named for their shape, 8.A or 8.B, and what are they called?

3. What is the name of the skirt worn by the woman in Figure 8.C?

 a. wheel farthingale

 b. drum farthingale

 c. French farthingale

 d. all of these

4. During the reign of which monarch was the skirt in Figure 8.C worn?

 a. Queen Katharine of Aragon

 b. Queen Elizabeth I

 c. King Henry VIII

 d. Queen Mary of England

5. What is the name of the garment around the neck of the man in Figure 8.C? What special treatment was it given to make it keep its shape?

6. What is the name of the decorative collar in Figure 8.D?

 a. conch

 b. suportasse

 c. ruff

 d. Medici collar

7. Did the decorative collar in Figure 8.D have a symbolic function?

 a. yes

 b. no

 c. scholars have differing opinions

8. Name the skirt-like garment Figure 8.E.

1. This chapter depicts royalty from different countries. Look closely at Figures 8.6a and 8.8. Compare and contrast the garments, including ornamentation, of these two dukes.

2. Look closely at Figures 8.11 and 8.13. Compare and contrast the young ladies' garment styles and accessories resulting from differences in fashions of their period.

3. Read Contemporary Comments 8.1 on page 217 of your textbook. Note the things the writer Philip Stubbes is objecting to, then look at the chapter's illustrations and choose a man's garment and a woman's garment that exemplify Stubbes's objections. Identify the items and explain your choices.

4. You have been asked to advise a designer who must costume a play about Henry VIII. You have agreed to share your textbook with him/her. Looking at the illustrations in Chapter 8, which one of these illustrations would you recommend for each of the following characters: Henry VIII, one of his wives, and his son? For each figure, make a list of six to eight essential details.

5. Which figure did you choose for the wife in Question 4 and why?

1. Trace the evolution of stocking manufacture in the 16th century. Why was this development necessary and how did it permanently improve stockings? (CO 8.5)

2. Relate the styles of silhouettes of men's breeches and women's skirts to the techniques used to provide support for these shapes, and compare their evolution during the 16th century. (CO 8.4)

3. Explain how royal marriages had an impact on popular fashions in the 16th century. (CO 8.2)

4. Items of dress are often named for their appearance or for the function or location of the item. What might be the origins of stomacher, bases, peascod belly, ruff, bum roll, duckbill, and points? (CO 8.1)

5. Agree or disagree with the statement "Religious conflicts had an impact on fashion change" and describe examples that support your opinion. (CO 8.3)

6. What were the differences, if any, between the clothing of children and that of adults in the 16th century?

Baroque and Rococo, 1600–1800

OVERVIEW

During the 17th century, Europe endured a crisis—a series of social and political upheavals involving civil war, revolts, peasant uprisings, and a rebellion against the nobility. This continent-wide crisis so shook the European nations that a stronger form of government—absolute monarchy—was needed to overcome it. By the 18th century, absolute monarchy was generally accepted everywhere in Europe except Great Britain, where the monarch's power had been limited as a result of the Glorious Revolution of 1688. The Baroque style, generally dated from the end of the 16th century to the middle of the 18th century, is the name given to the artistic style that developed during this period. From about 1720 to 1770, the rococo style supplanted the Baroque. Rococo styles were smaller and more delicate in scale than the Baroque and were marked by S- and C-curves, tracery, scrollwork, and fanciful adaptations of Chinese, classical, and even Gothic lines.

After completing the study of chapters in Part Four, answer the following questions.

IMAGE-BASED QUESTIONS

1. Compare and contrast the similarities and differences in menswear in the following figures.

 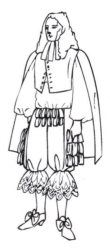

2. How does this figure demonstrate the Watteau back?

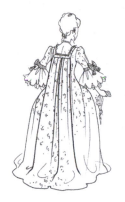

3. How does the panier depicted below help create the fashionable silhouette?

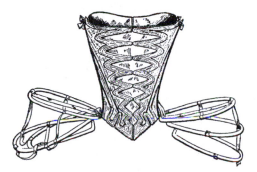

QUESTION FOR REFLECTION

Chapter 10 details the extensive sources of information about costume during the 18th century. What are these sources, and how do they provide evidence for the acceleration of fashion change during this century?

CHAPTER NINE

The Seventeenth Century, c. 1600–1700

CHAPTER OBJECTIVES

After studying this chapter, you will be able to:

9.1 Compare and contrast dress in 17th-century Europe and North America.
9.2 Examine children's dress developments in the 1600s.
9.3 Analyze possible 17th-century origins of present-day styles.
9.4 Describe the role of Louis XIV of France in shaping the directions of fashion at his court.
9.5 Explain the role of 17th-century religious conflicts in contemporary textile production and dress.

KEY COSTUME TERMS

Balagny	jack boots	pomander balls
basques	latchets	ribbons of childhood
biggins	leading strings	secret
canons	love lock	slap soles
carrying frocks	mantua/manteau	straight soles
cassocks/*casaques* (French)	modeste	surtouts/justacorps
cravat	muckinder	swaddling bands/stays/
draw loom	panes	staybands/rollers
drawers	pantofles	tailclouts/nappies/diapers
fontange	petticoat breeches/	tricorne
going frocks	rhinegraves	trunk hose
guardinfante	pinafore	virago sleeves
head rails	plumpers	waistcoat

HISTORIC SNAPSHOT

The major powers in 17th-century Europe were France, England, and Spain. Italy remained divided into small political units dominated by other countries. Holland had become independent of Spain, and the German princes, technically within the Holy Roman Empire, were sovereign powers. Colonial enterprises and trade continued to be a major source of revenue for the European powers. In the arts, Renaissance styles gave way to Mannerism and finally to Baroque styles.

SUMMARY OF THEMES

POLITICS	Monarchy is absolute. Dress plays a major role at the court of King Louis XIV of France. The king's requirements for fashionable dress prevent nobles from having the wealth to plot against him. Courtiers assist the king in his dressing rituals.
ECONOMICS	• Nobles at the court of Louis XIV spend vast sums on dress to meet the requirements for court functions. • French Protestant textile workers emigrate to other countries, including England.
CROSS-CULTURAL INFLUENCES	• A gift of a three-piece garment from a Middle Eastern ruler to the English King Charles II is considered to be a forerunner of the modern three-piece suit. The king wears the style at court and the style is widely praised by those who see it. • Western trade with East Asia expands, and imports like cottons and silks are prized.
SOCIETY	• In Spain, fashions change more slowly than the rest of Europe, probably as a result of a more conservative society. • "Ribbons of childhood" appear, marking the beginning of the idea of childhood as a separate stage of life. • Infants continue to be swaddled. • Boys wear skirts until the age of 6 or 7, after which they are dressed like men.
TECHNOLOGY	With the development of the printing press, people keep up with the latest changes in fashion through printed information and illustrations.
ARTS	Curvilinear lines and massive forms of the Baroque style replace more delicate Renaissance lines and forms, and the shapes of items of dress follow.
RELIGION	• French Protestants, called Huguenots, are expelled from France. Many Huguenots are skilled textile workers, and their departure negatively affects the supply of French textiles. • In England, conflict between Puritans and the Church of England yields differences in standards of dress between Puritans and Royalists.

Circle or write in your answers as needed.

Look carefully at the images, then answer the questions that follow.

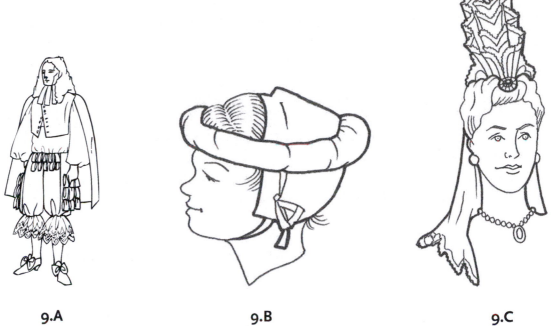

9.A 9.B 9.C

1. The name of the garment depicted in Figure 9.A is:

 a. petticoat breeches

 b. king's vest

 c. rhinegraves

 d. a and b

 e. a and c

2. The item depicted in Figure 9.B is:

 a. a swaddling band

 b. a pudding

 c. a muckinder

 d. a ribbon of childhood

3. The headdress in Figure 9.B signified that a child was of royal status.

 true

 false

4. The headdress in Figure 9.C originated in France.

 true

 false

5. In Figure 9.C, the towering headdress of ruffles adopted by 17th-century women was known in France as a _____ and in England as a _____.

6. The origin story about the headdress of ruffles in Figure 9.C involved a romantic incident between a lady and _____.

1. Compare Figures 9.2 and 9.14 in your textbook. Which one is a Puritan and which one a Royalist?

 a. Compare the way these women are dressed, noting the similarities and differences in headwear, neckwear, colors, fabrics, and so on. Which areas might reveal clues as to their religious choices, political affiliations, and status?

 b. Look at the children's clothes in each figure and identify any contrasts that would result from differences in age, religion, or social status.

 c. Compare the Puritan figure to your image of the stereotypes usually depicted in modern drawings of Pilgrims. How does this portrait differ from what you would have expected to see being worn by a Puritan woman?

2. Look at Figure 9.3 from the textbook. Flip back to Chapter 8 and study Figure 8.15. Compare these two illustrations and identify the differences between the two garments. Be sure to include the name of each garment, country of origin, and distinct features. Use this graphic organizer, or create your own on a separate sheet of paper.

	FIGURE 8.15	FIGURE 9.3
NAME		
COUNTRY		
CHARACTERISTICS		

3. Compare Figure 9.3 with Figure 9.11. Both were worn in Spain during a similar time period.

 a. What differences do you see between these styles? Similarities?

 b. How can you explain the differences in these two garments worn at the same general time period in some of the same places?

4. Look closely at Figure 9.18. Rewrite the caption to provide a better understanding of the importance of this style.

1. How did royalty directly influence fashions in dress during the 17th century? Provide examples to support your explanation. (CO 9.4)

2. How did the dress of Spanish upper-class men and women differ from the dress of upper-class men and women in other European countries? Identify factors that seem to have been the basis for these differences.

3. How did the clothing of members of the Puritan and Royalist factions differ during the English Civil War? What seems to have been the basis for these differences? (CO 9.5)

4. In two or three sentences, summarize the differences between 17th-century dress in England and in English North American colonies. (CO 9.1)

5. Compare scholars' opinions about children's dress in your textbook and explain which view you find most convincing and why. (CO 9.2)

6. The origins of the modern three-piece suit are said to be found in the 17th century. How did contemporary figures feel about this new style, and why did it get so much attention? (CO 9.3)

7. Identify similarities and differences between children's dress and adults' dress of the 17th century. (CO 9.2)

CHAPTER TEN

The Eighteenth Century, 1700–1790

CHAPTER OBJECTIVES

After studying this chapter, you will be able to:

10.1 Identify events and individuals that influenced fashions in the dress of 18th-century men, women, and children.

10.2 Draw connections between undergarments and changes in the silhouette of 18th-century women's dress.

10.3 Compare how social life affected the dress that was worn in France, England, and the American colonies.

10.4 Describe elements in the dress of the wealthy and of the working class that illustrate conspicuous consumption.

10.5 Contrast philosopher Jean-Jacques Rousseau's 18th-century recommendations about children's dress with practices followed in earlier centuries and explain what the changes would accomplish.

KEY COSTUME TERMS

Anglomania
artificial calves
beau/coxcomb/fop
bergere/shepherdess hat
bicorne
boot cuff
bustle/false rump
calash/calech
caraçao
casaquin
chapeau bras
chemise à la reine
club wig/catogan
engageant
eschelle
fall
fashion baby
frock/frock coat
full-bottomed wig
full dress

greatcoat
habit
hedgehog
hoop
Indian gown/banyan
jump
latchet
macaroni
mantua
mob cap
mules
paniers
pet en l'air
pinner
polonaise
powdering jacket
queue
redingote dress
robe à la Française
robe à l'Anglaise

round gown
round hat
sacque (robe battante, robe volante, or innocente)
short gown
skeleton suit
smock
spatterdashers/spats/gaiters
stay
steinkirk
stock
stomacher
tête de mouton
tippet
toupee (French)/foretop (English)
tricorne
Watteau back

83

HISTORIC SNAPSHOT

Despite costly wars and a mounting fiscal crisis, France dominated the culture of western Europe throughout the first half of the 18th century. The lavish court contrasted sharply with the lives of ordinary citizens, and by the second half of the century, Frenchmen who wanted reform were encouraged not only by the success of the American Revolution, but also by English influence, particularly in the areas of government and civil rights. In 1789, the bankruptcy of the French government forced the calling of the Estates General, which declared itself a National Assembly, abolished feudalism, and began to write a constitution. In 1793, the king and queen of France were executed and the old regime was abolished.

Georgian England was ruled by the Hanoverian kings, who were of German extraction. The organization of society was less court-centered in England than in France, and both the upper class and the growing middle class kept up with fashion, vacationed at spas, and took part in various forms of popular entertainment where they might observe the latest fashions.

During this period, the Baroque style gave way to the more curvilinear forms of the Rococo, which were replaced in the last half of the century by a revival of Classical influences in the Neoclassical Period. Also during this period, international trade brought Asian influences to Europe, and advances in textile technology foreshadowed the Industrial Revolution.

SUMMARY OF THEMES

SOCIETY	• Clothing of less-affluent people and servants is simple and practical, with some general reflection of the lines of fashionable dress. These differences in style reinforce class distinctions. The fairly decorative dress of servants of the nobility is a statement of a sort of reflected glory, as if the status of the master would be diminished if his servant were inadequately attired. • Greater freedom in clothing for children reflects the child-rearing methods of the period. • Quaker men avoid wearing fashionable wigs, and both men and women of the Quaker faith wear subdued colors without elaborate embellishments.
ECONOMICS	• The enormous amount of hand labor required to make both men's and women's clothing shows not only the wealth of the owner, but also the ready availability of low-paid men and women who spend hours sewing and embroidering these garments. • The lavishness of 18th-century clothing illustrates the principle of conspicuous consumption (showing one's wealth through owning and displaying valuable objects). Conspicuous leisure (demonstrating that one does not need to work) is evident in the inconvenience of the tall headdresses and wide paniers, because the wearers could not possibly be accused of doing any productive work!
POLITICS	The variability of styles, the extremes of size and shape, and the lavishness of decoration may be a frantic attempt on the part of the French nobility to escape the conflicts that will shortly lead to the bloody French Revolution, whereas women of the new American democracy powder their hair and don paniers. American styles are less extreme and lag a little behind those of the European courts.
CROSS-CULTURAL INFLUENCES	• International trade gives rise to the use of Indian chintzes, muslins, and Asian designs of woven brocades and damasks, as well as new styles in shoes and men's robes or dressing gowns. • Fringed buckskin clothes for American men demonstrate the cross-cultural influence of Native American dress on American settlers.
TECHNOLOGY	Technological advances expand textile availability and lead to lower fabric costs.

Circle or write in your answers as needed.

Look carefully at the images, then answer the questions that follow.

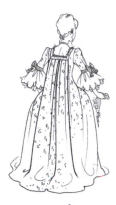

10.A

10.B

10.C

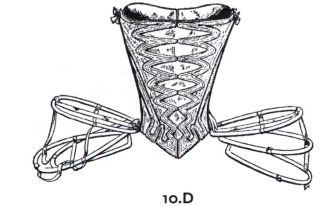

10.D

10.E

1. Figure 10.A is named after an artist. Who is the artist, when did this name develop, and why was it applied to this style?

2. The garment in Figure 10.A is characteristic of which one of these dress styles?

 a. saque dresses

 b. robe à l'Anglaise

 c. robe à la Francaise

 d. chemise a la reine

3. What are the names applied to the headwear in Figures 10.B and 10.C?

 a. jockey cap and calash

 b. tricorne and bicorne

 c. chapeau bras and tricorne

 d. chapeau bras and bicorne

4. Figures 10.B and 10.C were not given their names until the 19th century.

true

false

5. What is the name given to the garment depicted in Figure 10.D?

 a. bustle

 b. hoop

 c. paniers

 d. pet en lair

 e. b and c

6. Dresses worn over the garment in Figure 10.D were likely to have which of these features?

 a. casaquin

 b. engageants

 c. a fall

 d. eschelles

 e. b and d

7. In which part of the 18th century was the garment depicted in Figure 10.E worn?

 a. first half

 b. second half

 c. whole

8. When the man in Figure 10.E went outdoors, he might wear a banyan.

 true

 false

VISUAL OR PRIMARY SOURCE ANALYSIS EXERCISES

1. You are assigned to costume a play set at the time of Queen Marie Antoinette (before the French Revolution) and need to provide costumes for actors playing the parts listed below. Fill in the table by identifying the illustration in Chapter 10 that you would use for each character. Give the reasons that you selected these items.

CHARACTER	GARMENT AND FIGURE TO USE	REASONS FOR CHOICE
UPPER CLASS MAN WORKING IN HIS STUDY, BUT POSSIBLY GOING OUTSIDE ON A BRIEF ERRAND		
SERVANT HELPING HER WEALTHY MISTRESS DRESS		
WIFE OF UPPER-CLASS MAN WANTING TO IMITATE THE QUEEN AT COURT		
4-YEAR-OLD BOY DRESSED BY HIS MOTHER FOR A VISIT FROM HIS GRANDMOTHER		

2. Look closely at Figure 3.4 from Chapter 3 in your textbook and at Figure 10.19. Why do you think there is less disagreement about what women wore in the 18th century than about Minoan women's dress?

3. Review the illustrations of men's dress in Chapter 10 and select one item that could be used to illustrate the principle of conspicuous consumption. Why did you make this choice?

4. Compare Figures 10.3 and 10.18. Both figures depict dress of servants. How can you explain the considerable differences in their dress? Make up a story in a few lines about the life of each servant that would explain the differences.

CRITICAL THINKING EXERCISES

1. A number of French women were important at different times during the 1700s. Who were Madame de Pompadour and Queen Marie Antoinette, and why was each important to fashion and history? (CO 10.1)

2. If you were transported back to 18th-century England, why might you have difficulty understanding what people were talking about when they discussed clothes? Give examples of terms used and their meanings that illustrate your answer. (CO 10.2)

3. Why is it easier to research 18th-century dress than that of earlier periods? What art traditions in portraiture make it difficult to determine what people actually wore?

4. Explain how social life in France, England, and the American colonies contributed to choices of dress that was worn for various times of day and for special occasions. (CO 10.3)

5. How did the philosopher Jean-Jacques Rousseau influence children's dress in the second half of the 18th century? What were some of his recommendations? (CO 10.5)

6. How does Thorstein Veblen's theory of the leisure classes reflect the 18th-century economy? List some examples of how fashions of the period demonstrated this theory. (CO 10.4)

The Nineteenth Century, 1800–1900

OVERVIEW

The 19th century was a time of great, kaleidoscopic growth and change in both Europe and the United States, with resulting changes in dress. The Industrial Revolution, which had begun in the preceding century, accelerated during the 19th century, resulting in increased production of goods, namely the Kashmir and paisley shawl, at lower prices. Though work was often harsh and cruel, for many it ultimately provided a higher standard of living. Although they had different characteristics, the clothing styles of men and women up to about the French Revolution were equally grand and elaborate. With changes in occupations for men that stemmed from the Industrial Revolution, this changed. The essence of fine clothing for men was in the cut and tailoring, rather than in ornamentation. The variety of choices decreased and decoration diminished; however, fashion change continued to occur.

After completing the study of chapters in Part Five, answer the following questions.

IMAGE-BASED QUESTIONS

1. Describe how menswear changes using the following figures.

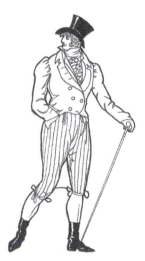 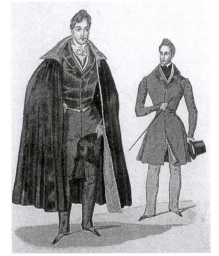 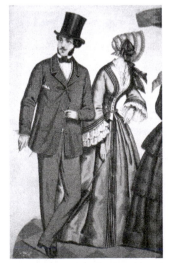

2. Which of these figures includes leg-of-mutton sleeves? Which of these figures includes a bustle?

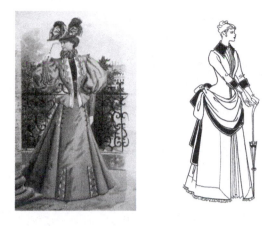

3. How is the children's wear below similar to and different from characteristic adult wear of the period?

QUESTION FOR REFLECTION

Societal events such as the French Revolution and technological advancements such as the Industrial Revolution impacted the fashionable dress covered in the chapters of Part Five. Detail which societal events and technological changes within your lifetime have affected fashionable dress.

The Directoire Period and the Empire Period, 1790–1820

CHAPTER OBJECTIVES

After studying this chapter, you will be able to:

11.1 Identify elements that Europeans and Native Americans incorporated and adapted from each other's dress.

11.2 Relate changes in men's and women's fashions to political events of the Empire Period.

11.3 Identify aspects of Empire Period dress in which earlier styles are revived.

11.4 Compare and contrast the dress worn by children and adults in the Empire Period.

11.5 Explain the contributions to Empire Period fashion that came from international trade.

KEY COSTUME TERMS

à la victime/à la Titus	habit shirt	round gowns
bicorne	high stomacher dress	sans culottes
bonnet rouge	holoku	skeleton suit
carmagnole	moccasins	spencer
chapeau bras	muslin fever	stock
cravat	pantalettes	top hat
dandy	pantaloons	toque
day cap	pelisse	
dressing gown/banyan	quizzing glasses	
gypsy hat	reticule/ridicule	

HISTORIC SNAPSHOT

During the Directoire and Empire Periods, fashions took on greater symbolic meanings, owing to dramatic social and political upheaval, and differences with previous styles became pronounced. The Directoire Period (c. 1790–1800) includes major events in the French Revolution and the establishment of the Directory, a government by a five-man executive body. The Empire Period coincides generally with the period during which Napoleon Bonaparte was head of state, extending his power over all of Europe and defeating all but Great Britain—which remained at war with France until Napoleon's defeat at Waterloo in 1805.

In North America, the continuing expansion of the U.S. frontier brought Native American and European populations into frequent contact, and European settlers adopted or adapted some forms of Native American dress, although the major styles continued to parallel those of Europe. Native Americans in turn added goods gained in trade to their apparel items. The Industrial Revolution stimulated the production of lower-cost fabrics, especially those made of cotton in the South.

SUMMARY OF THEMES

POLITICS	The French Revolution and subsequent political changes of the Directoire Period yield fashion changes and, ultimately, dramatic changes in dress practices, such as the change for men from knee breeches to trousers.
ECONOMICS	Machine-made cotton fabrics replace expensive imported cotton fabrics, thereby increasing demand. As a result, cotton production increases in the American South. Plantation owners rely on enslaved workers to produce the fiber, leading to demands to increase the slave trade.
CROSS-CULTURAL INFLUENCES	• Fashion in Europe and America elevates textiles imported from China and India and cashmere shawls from India. • Europeans and Native Americans adapt elements of each other's dress into their own (in a process termed "cultural authentication" by later scholars).
SOCIETY	• The French Estates General, an assembly representing the population, regulates dress signifying a man's place in society. • During the French Revolution, people wear certain items of costume to proclaim support for the Revolution. • Anti-slavery sentiments in the northern United States lead to the beginnings of abolition of slavery in the North.
TECHNOLOGY	The growth of the textile industry accelerates with the Industrial Revolution. Cotton production takes off in the American South with the invention of Eli Whitney's cotton gin. Adoption of water or steam to power textile mills helps make cotton affordable and available. In France, Joseph Marie Jacquard develops a mechanized loom for weaving patterned fabrics. Such technological changes lead to the increasing availability of ready-made garments for men.
ARTS	The Neoclassical style revives Greek and Roman motifs in architecture and in fashion with dresses with strong similarities to women's dress in Greece and Rome.

Circle or write in your answers as needed.

Look carefully at the images, then answer the questions that follow.

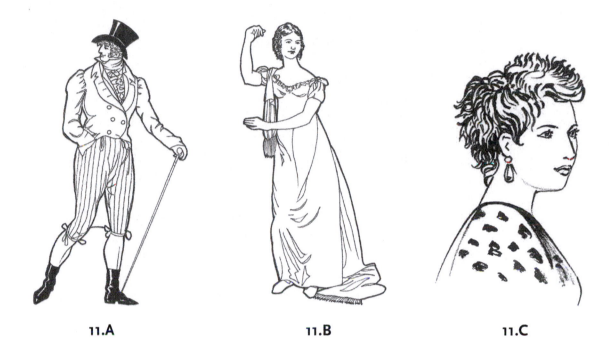

11.A 11.B 11.C

1. What is the name for the type of trousers in Figure 11.A?

 a. pantaloons

 b. trousers

 c. knee breeches

 d. none of these

2. What is the name of the jacket in Figure 11.A?

 a. spencer

 b. doublet

 c. tail coat

 d. great coat

3. What is the name of the hat in Figure 11.A?

 a. chapeau bras

 b. bicorne

 c. tricorne

 d. none of the above

4. In Figure 11.B, the woman's dress is likely to be made either of _____ fiber or _____ fiber.

5. The hairstyle in Figure 11.C was known as _____ or as _____.

6. The haircut in Figure 11.C was named after _____.

7. Empress Josephine supported Napoleon's ban on imported shawls by giving hers away.

 true

 false

8. Respiratory infections were known as muslin fever because the popular muslin dresses were so lightweight that it was thought that women were likely to become chilled and catch pneumonia.

 true

 false

1. Look up Figure 11.3 in your textbook. This caption depicts a man and a woman in extreme styles but does not describe what makes them extreme. Add text to the caption that would explain to someone just what the extreme styles of these people would have been.

2. Compare and contrast the dress depicted in Figure 11.5 with Figure 3.14 in Chapter 3. Find two or three similarities and two or three differences. Do you think it is accurate to say that Directoire Period women's dress was probably inspired by ancient Greek styles? Cite the evidence that supports your opinion.

3. Look up Figure 11.14 in your textbook. Compare and contrast the costume of all three males, citing not only type of garment but also details.

4. Look at Figure 11.5. Who is the woman in this painting? In what country would she be living? Why is it possible to say that this illustration has an extensive relationship to the themes of international trade, fashion, and status?

CRITICAL THINKING QUESTIONS

1. Explore the effects of politics and political conflict on dress during the French Revolution. For example, how was clothing used to directly express political positions? How did clothing express political positions indirectly during the war? (CO 11.2)

2. Compare and contrast men's clothing styles of the Empire Period with those of the 18th century. What major changes in men's dress occurred at this time? (CO 11.3)

3. In Chapter 1, the term *cultural authentication* is defined as "the process 'whereby elements of dress of one culture are incorporated into the dress of another.'" What items of European dress were embraced by Native Hawaiians, and how were they transformed? What items of Native American dress were embraced by Europeans, and how were they transformed? Now define the term *cultural authentication* in your own words. (CO 11.1)

4. How were specific fashionable dress and accessory items made possible by international trade? Identify some specific items and explain their origins. (CO 11.5)

5. How did women's dress silhouettes change during the Empire Period? What impact did this these changes have on underclothing and accessories?

6. How and when did boys' clothing differ from girls' clothing? How and at what stage of children's development did their clothing differ from that of adults? Describe these differences and explain why they mattered. (CO 11.4)

The Romantic Period, 1820–1850

CHAPTER OBJECTIVES
After studying this chapter, you will be able to:

12.1 Compare and contrast the changes in women's and men's dress in this period.

12.2 Evaluate the sources of information about dress worn in the Romantic Period.

12.3 Relate attitudes expressed in Romantic art and literature to some specific dress styles.

12.4 Describe the ways enslaved people's clothes were used to emphasize their status.

12.5 Identify the key points within this period when women's dress silhouettes changed, and what the changes were.

KEY COSTUME TERMS

bavolet	derby hat (U.S.)/bowler (UK)	mancherons
berthas	drawn bonnet	Newmarket
bishop sleeve	Eton suit	paletot
box coats/curricle coat	filler/chemisette/tucker	pardessus
burnous	gibus hat	pelerine
bustle	gigot/leg-of-mutton sleeve	pelerine-mantlet
canezou	gilet corsage	pelisse-robe
capotes	hussar front/beak	ruching
carriage parasol	imbecile/idiot sleeve	santon
chesterfield	leglets	spatterdashers/spats
demi-gigot sleeve	mackintosh	Victorian

HISTORIC SNAPSHOT
Romanticism in literature, music, graphic arts, and dress represented a reaction against the formal Classical styles of the 17th and 18th centuries. Romantics were nonconformists who believed in fierce emotion and a mythologized view of the past. The Romantic lifestyle included wearing beards, long hair, and costumes that showed conscious attempts to revive elements of historical dress. The influence of Romanticism flourished from 1820–1840 and declined after the revolution in France (1848–1849).

In England, Parliament extended voting rights to more men, and in 1837, Victoria became queen. In France, the Bourbon monarchy was restored, but unwillingness to make reforms helped lead to the outbreak of revolution in 1848, and a wave of revolution swept over Austria, the German states, and Italy. Meanwhile, in the United States, westward expansion had begun, and by the mid-19th century, the cultivation of cotton dominated the economy of the southern states. Because of cotton, the South was identified with slavery, a condition that separated the South from the North.

During this period, women's magazines included depictions of popular fashions. Some types of ready-made clothes were available for men, but for women, clothing was still largely made by seamstresses or at home.

SUMMARY OF THEMES

POLITICS	Royalty influences fashions in both England and France. The accession of Queen Victoria is greeted with pleasure in England. In the early Romantic Period, the French royalty return to the throne and styles associated with earlier monarchs are revived.
ECONOMICS	Many more consumers buy Jacquard-woven paisley shawls and machine-made lace, fashions made affordable by the Industrial Revolution.
SOCIETY	Women's dress is far more colorful and elaborate than men's, which tend to be in neutral and subdued colors and plainer styles.
TECHNOLOGY	The production of fabrics such as lace and elaborately patterned Jacquard-woven fabrics is mechanized.
ARTS	The Romantics hark back to past historical periods for inspiration in fashion and fine and applied arts.
SOCIAL ISSUES	Slavery comes to public attention through the work of abolitionists in the northern United States. The dress of enslaved people reflects their oppression.

Circle or write in your answers as needed.

Look carefully at the images, then answer the questions that follow.

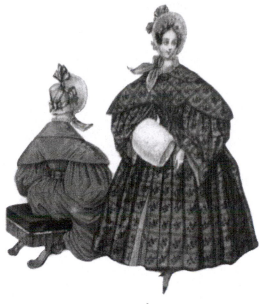

12.A

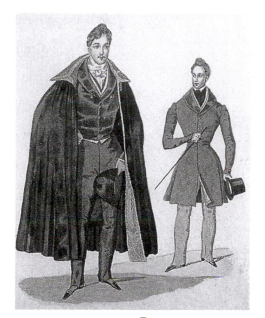

12.B

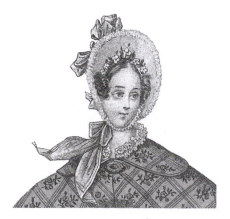

12.C

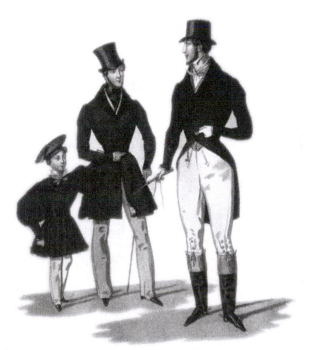

12.D

1. What is the garment in Figure 12.A called?

 a. fichu

 b. pelisse

 c. banyan

2. What is the name of the type of sleeve in Figure 12.A?

 a. leg-of-mutton sleeve

 b. imbecile sleeve

 c. Marie sleeve

 d. cap sleeve

3. In Figure 12.B, the coat worn by the man on the right is a:

 a. tailcoat

 b. riding coat

 c. frock coat

 d. sack jacket

4. In Figure 12.B, the man on the left is wearing clothes for business.

 true

 false

5. The style of headcovering depicted in Figure 12.C is a

 a. toque

 b. top hat

 c. bonnet

 d. day cap

6. The dress of the men in Figure 12.D includes examples of these garments: waist coat, top hat, trousers, mitts, frock coat.

 true

 false

If you chose "false," draw a line through any items in the sentence that they are not wearing.

VISUAL OR PRIMARY SOURCE ANALYSIS EXERCISES

1. Sleeve style variations are an interesting feature of women's dress in the Romantic Period. Look closely at Figures 12.8, 12.9, and 12.20, their captions, and the corresponding text. What are the names of the sleeve variations that you can see in women's dress that are depicted in these figures? At about what date do sleeves become less elaborate?

2. Look up Figures 12.6 and 12.16 in your textbook. Do the sleeves of men's or children's dress show any similarity to women's dress? If they do, what is the name of the sleeve type?

3. Look at Figure 12.13. This caption states that the illustration contrasts the styles of the early Romantic Period to those of the later Romantic Period but does not identify the differences. Expand the caption to identify the differences that are evident in this illustration.

4. Look up Figures 12.15, 12.16, and 12.17 in your textbook. Which of the "artificial assistants" depicted in Figure 12.15 do you think the men in Figure 12.16 might use to get their garments to fit well? What about Figure 12.17?

CRITICAL THINKING QUESTIONS

1. The relationships between costume and developments in the fine and applied arts run through costume history. Describe how the Romantic movement in the arts was reflected in costume of the Romantic Period. (CO 12.3)

2. What Romantic-period sources would you look at to learn about the differences between the clothing of affluent women and the clothing of women from lower socioeconomic classes? How did these differences relate to differences in their respective social roles? (CO 12.2)

3. Describe the sources of information about costume after the 1830s that provide costume historians with more extensive and more accurate information about styles than earlier periods. Compare the strengths and weaknesses of these resources. (CO 12.2)

4. Fashion is often described as evolving rather than changing radically. Describe the gradual evolution in women's dresses between 1820 and 1850, noting changes in hemlines, waistline placement, sleeve shapes, and skirt shapes. Also note points at which more radical changes took place. (CO 12.5)

5. How did changes in the silhouette of men's coats parallel changes in the silhouette of women's dresses during the Romantic Period? (CO 12.1)

6. Summarize the types of the sources that costume historians have used to gather information about enslaved people's clothing. What generalizations can you make about the dress of enslaved people based upon the sources? What kind of information is not easily available? (CO 12.4)

CHAPTER THIRTEEN

The Crinoline Period, 1850–1869

CHAPTER OBJECTIVES

After studying this chapter, you will be able to:

13.1 Assess the importance of technology to fashion in dress of the Crinoline Period.

13.2 Trace the changes in the silhouettes of skirts during the Crinoline Period.

13.3 Define dress reform and describe the results of attempts to introduce this idea.

13.4 Describe the beginnings and development of haute couture in France.

13.5 Identify sources of military influence on dress for women and children in the Crinoline Period.

KEY COSTUME TERMS

basques	Inverness cape	raglan cape
bergere	knickerbockers	reefer/pea jacket
bloomer costume	mauve	rotonde
burnous	morning coat/riding coat/	sack jacket/lounging jacket
cage crinoline/crinoline	Newmarket coat	(UK)
canezou	pagoda sleeves	shawl-mantle
carriage parasol	paletot	Stetson
chesterfield	pardessus	Swiss belt
day cap	pelisse-mantle	talma-mantle
frock overcoat	pork pie hat	Zouave jacket
garibaldi blouse	princess dress	

HISTORIC SNAPSHOT

This period was named for the cage crinoline, a device for holding out women's skirts. In England during this era, the ideal of womanhood was wife and mother, epitomized by the country's young queen, Victoria. England enjoyed prosperity and industrial growth,

and other nations strove to emulate its success. In France, Charles Frederick Worth, considered to be the first designer of the French haute couture, helped Paris become the fashion center of Europe. The city had passed its bloody days of revolution, and during the Second Empire France regained the leadership of Europe and Paris became a world capital. Although France's fortunes started to decline by the 1860s, Paris remained the world's fashion capital.

In the United States, the nation was bound together by a growing network of turnpikes, rivers, canals, and railroads. Manufacturing output in the northeastern states surpassed the value of southern agricultural products. The foundations of public school education had been established, and the women's rights movement had begun. The discovery of gold in California in 1848 sparked the Gold Rush, and the United States was divided by the Civil War (1861–1865).

SUMMARY OF THEMES

POLITICS	• During the Civil War, Americans adopt fashions influenced by the Zouave-inspired uniforms of some northern troops. • In Italy, garibaldi blouses imitate the red shirts worn by Italian troops fighting for independence.
ECONOMICS	• Businessman Levi Strauss introduces blue jeans at the time of the California gold rush. His firm thrives. • Isaac Singer's innovations encourage sales of his sewing machines.
CROSS-CULTURAL INFLUENCES	• Enslaved women bring the tradition of wearing headscarves from Africa to the American South. • French fashion styles become even more influential with the founding of the French couture.
SOCIETY	• The women's rights movement attempts to encourage dress reform, but with relatively little success. • Dress restrictions on enslaved people come to an end with the Civil War.
TECHNOLOGY	• Metallurgical advances make development of the cage crinoline possible. • Sewing machines change the way in which dress is created.
ARTS	• Fashion designs by talented designers come to be considered a form of art; Charles Worth is the first designer to become a recognized innovator. • By the time of the Crinoline Period, photography is well-developed.

Circle or write in your answers as needed.

Look carefully at the images, then answer the questions that follow.

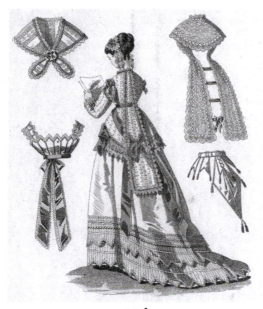

13.A

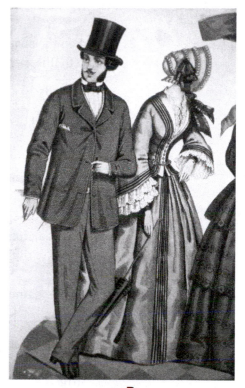

13.B

13.D

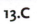

13.C

1. The ornamentation on the woman's dress in Figure 13.A includes:

 a. pleating

 b. vandyking

 c. lace

 d. all of the above

2. Based on the shape of the dress in Figure 13.A, which of the following dates would you assign to this garment?

 a. 1850

 b. 1861

 c. 1869

 Give reasons for your choice.

3. What is the name of the hat on the man in Figure 13.B?

4. What is the name of the man's jacket in Figure 13.B?

5. The jacket style in Figure 13.B had been worn since the end of the French Revolution.

 true

 false

6. What is the name of the garment worn by both the boy and girl in Figure 13.C?

 a. skeleton outfit

 b. garibaldi costume

 c. Zouave jacket

 d. spencer jacket

7. What did Americans call the hat in Figure 13.D?

 a. deerstalker

 b. bowler

 c. derby

 d. b and c

8. What did the British call the hat in Figure 13.D?

 a. deerstalker

 b. bowler

 c. derby

 d. b and c

VISUAL OR PRIMARY SOURCE ANALYSIS EXERCISES

1. Look closely at Figure 13.11. What is the medium (e.g., painting, drawing, engraving) used to make this illustration? What information about dress can you glean from illustrations in this medium?

2. Choose one of the photographs from Figure 13.9 in your textbook. Give the letter of the illustration. What aspects of women's dress can you learn about from this illustration?

3. Look closely at Figure 13.16. What is the medium (e.g., painting, drawing, engraving) used to make this illustration? What clues about dress can you detect from illustrations in this medium?

4. Examine Figures 13.6 and 13.17b in your textbook. What can you learn about men's dress from these photographs?

5. Compare the man in Figure 13.16 with the children in Figures 13.17a and b. Summarize the advantages and disadvantages of using photos versus other media. In what ways can you benefit from having different types of primary sources?

1. Assess the effects on fashion of some of the innovations that Charles Worth (and his sons) brought to the fashion design industry in France. (CO 13.4)

2. How did technological advances affect dress during the Crinoline Period? What was the impact of those advancements? (CO 13.1)

3. How was women's and children's costume during the Crinoline Period inspired by military clothing? Cite specific items and conflicts in your answer. (CO 13.5)

4. Fashion is often said to evolve gradually. Describe the gradual evolution in women's skirt styles in the Crinoline Period. How were these changes enabled by undergarments? (CO 13.2)

5. Identify Amelia Bloomer and relate her to the cause she wanted to promote through her dress. Describe the effects of her efforts. (CO 13.3)

6. How did southern women cope with the shortages of supplies during the Civil War? How did they attempt to keep up with fashion?

The Bustle Period and the Nineties, 1870–1900

CHAPTER OBJECTIVES

After studying this chapter, you will be able to:

14.1 Describe the beginnings of apparel manufacturing and its effect on how clothing was acquired.

14.2 Compare men's clothing at the beginning of the 20th century with that at the end of the 19th century.

14.3 Relate changes in dress silhouettes to changes in undergarments for women.

14.4 Identify the ways in which popular art influenced dress of the period.

14.5 Analyze the effect of women's increased participation in sports on changes in how they dressed.

KEY COSTUME TERMS

bustle	jersey fabric	pompadour
clocks	Kate Greenaway styles	shirtwaist/waist
combination	knickers (U.S.)/rationals	tailor-made
cuirass bodice	(UK)	tea gown
dolman	leg-of-mutton sleeves	tuxedo
fedora	Liberty prints	ulster
Gibson girl	Little Lord Fauntleroy suit	union suit
Gibson men	morning coats	
homburg	Norfolk jacket	

HISTORIC SNAPSHOT

The Bustle Period derived its name from the device that provided the shaping for a skirt silhouette with marked back fullness. The last decade of the 19th century was called "The Gay Nineties" or, in France, "La Belle Époque." Both names convey a sense of fun and good humor.

Ruled by Queen Victoria, the British Empire had grown to include lands across the world, and industrial England was in the midst of a great economic boom. There was a gradual extension of voting rights, and passage of legislation to clean up the slums and improve sanitary conditions. Although the social conventions of Victorian England continued, there were signs of changing attitudes. In France the Second Empire was replaced by the Third Republic, and in the United States the Civil War had ended and industrialization, urbanization, and immigration were continuing apace.

During this period, women were beginning to enter the workforce and participate in sports, especially bicycling. The invention of the sewing machine facilitated the movement to mass production, which contributed to the development of the garment industry and ready-made clothes. Many stores had begun to publish mail-order catalogs.

SUMMARY OF THEMES

POLITICS	• The British establish an Empire, which facilitates trade with colonies around the world, and the U.S. opening of trade with Japan results in the importation of textiles and the incorporation of influences from abroad in fashionable dress. • The United States builds the transcontinental railroad, furthering its westward expansion.
ECONOMICS	• Immigrant labor with skills in sewing and tailoring benefits mass production of fashionable dress in the United States. • The entry of women into the workforce stimulates demand for ready-made dress for women, who no longer have time to make their family's apparel. • American consumers enjoy ease of national distribution of products used in dress, especially after mail-order catalogs become available.
CROSS-CULTURAL INFLUENCES	European and American imperialism brings Western dress and fashions to countries around the world where traditional dress had previously dominated. At the same time, influences from elsewhere come to Europe and America.
SOCIETY	Middle- and upper-class society still consider a woman's place to be in the home, however, more and more women contribute to the family income by working outside the home.
TECHNOLOGY	• Sewing machines and other mechanical devices benefit both home sewers and clothing manufacturers. • The transcontinental railroad connects the eastern United States with the west.
ARTS	Historic styles influence architecture, home furnishings, and fashions. Styles are often named after historic figures. The period is marked by art movements such as Aesthetic Dress, and in the 1890s, Art Nouveau. Influences from all these movements appear in fashions.
RELIGION AND ETHICS	Awareness of the possible negative effects on women's health of tight corseting and restrictive dress leads to dress reform of women's garments. More women engage in active sports, especially when bicycling becomes a fad, and special dress is made to keep ladies from displaying their legs while riding.

Circle or write in your answers as needed.

Look carefully at the images, then answer the questions that follow.

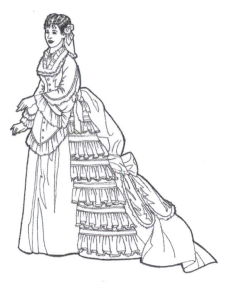

14.A

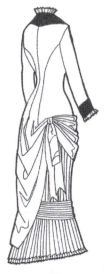

14.B

14.C

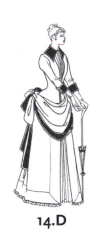

14.D

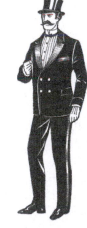

14.E

1. Write the corresponding figure number next to each phrase.

 a. _____ Back fullness drops low, near the floor.

 b. _____ The only remaining evidence of a bustle is a few pleats.

 c. _____ The bustle has a waterfall effect.

 d. _____ The bustle is shelf-like.

2. Which of the women is wearing a cuirass bodice?

3. Which of the women is wearing a tailor-made?

4. Which of the women's garments has leg-of-mutton sleeves?

5. Which of the women would be wearing a large bustle under her dress?

6. The man in Figure 14.E is dressed for business.

 true

 false

7. The man in Figure 14.E is wearing a style that originated in the 1880s.

 true

 false

8. The man in Figure 14.E is wearing a style that originated in the United States.

 true

 false

1. Imagine that you are a seamstress or a tailor in the 1870s, when styles are transitioning from the Crinoline to the Bustle Period. A customer wants you to update a garment from the late 1860s and make it into a daytime dress that is in keeping with the styles of the first phase of the Bustle Period. In order to get a handle on the job, you study Figure 14.6, and look also at other illustrations in Chapters 13 and 14.

 a. What aspects of the late Crinoline Period styles will make your job easier?

 b. What aspects of the first phase of the Bustle Period will make your job more difficult?

 c. Figure 14.6 places two garments from these two periods side by side. However one is an evening dress and one a daytime dress. You want to make a daytime dress. What differences are there in a daytime dress when compared to an evening dress? In what part of the dress will you need to add additional fabric so it is suitable for daytime wear?

2. Look at Illustrated Table 14.1. What kinds of undergarments shown on the table will be needed to create the full bustle effect? Give reasons for your choices.

3. Read Contemporary Comments 14.1. Look through the illustrations of women's dress in Chapter 14 and identify four figures that you could use to illustrate the negative health effects described in the Contemporary Comments feature. Explain why you selected each item.

1. What effect did the participation of women in sports have on women's clothing styles between 1870 and 1900? To what extent was clothing designed and worn for specific sports? (CO 14.5)

2. Several factors led to increased manufacturing of ready-to-wear clothing during the last decades of the 19th century. What were a few of these factors? (CO 14.1)

3. Explain how the Aesthetic Movement sought reform both in the arts and in clothing. List some specific costume items that originated either directly or indirectly from the Aesthetic Movement, and explain their origins.

4. What was Art Nouveau? How did the Art Nouveau influence appear in costume? (CO 14.4)

5. Explain how changes in the shape of women's garments from the Crinoline Period to the Bustle Period resulted in changes in the corsets of each period. (CO 14.3)

6. Compare men's dress at the end of the 19th century with that at the beginning of the 19th century. What major changes and innovations took place during this time? Which changes have persisted up to the present time, and which have not? (CO 14.2)

From the Twentieth to the Twenty-first Century, 1900–2014

OVERVIEW

The beginning of the 20th century was, for many, almost a magical period. It seemed to mark a turning point—a new era—and it was punctuated by special celebrations, expositions, pronouncements by public officials, and a rash of predictions about what the world would be like by the turn of the next century. Throughout the remainder of the 20th century, many societal, political, technological, and economic changes would take place. These changes would all affect the fashions of each period. Additional media sources emerged in the 20th century that greatly inform dress historians' knowledge of the past.

After completing the study of chapters in Part Six, answer the following questions.

IMAGE-BASED QUESTIONS

1. Describe how political conflict affected the dress depicted in these two figures.

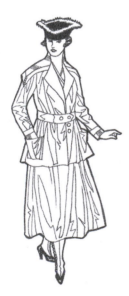 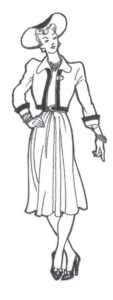

2. What changes occurred in menswear in the following figures?

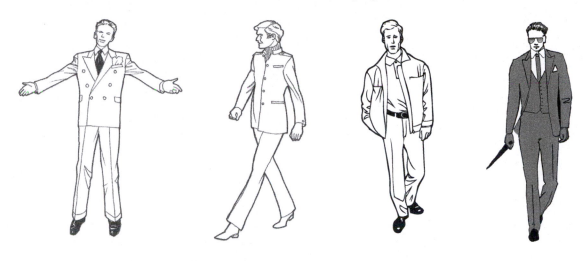

3. Describe the New Look as depicted in the following figure.

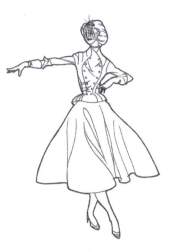

QUESTION FOR REFLECTION

Throughout the 20th and 21st centuries, the media have reflected and influenced fashion. What part do movies, television, and the Internet play in the way you live? How do you anticipate media influencing you in your career?

The Edwardian Period and World War I, 1900–1920

CHAPTER OBJECTIVES

After studying this chapter, you will be able to:

15.1 Name the prevailing garment names and silhouettes of the period 1900 to 1920.

15.2 Explain how changes in technology in everyday life and social changes helped to establish less-confining and more practical garment styles for women.

15.3 Demonstrate how individual fashion designers influenced the prevailing garment styles.

15.4 Support the view that World War I directly affected styles of the period.

15.5 Evaluate the notion that children's wear became more practical during this period.

KEY COSTUME TERMS

bishop sleeve	jabots	Poiret, Paul
blazer	jodhpurs	pompadour
brassiere	knickers	pullover
cami-knickers	lingerie dress	sport jacket
Delphos gown	lounge coat	tailor-made
duster	minaret tunic	tea gown
four-in-hand	peg-top skirt	top coat
goring	picture hat	wrapper

HISTORIC SNAPSHOT

Prince Edward, whose name is generally applied to the first decade of the century, brought to England an emphasis on social life and fashion. In France, innovative designers such as Paul Poiret and Mariano Fortuny established themselves as fashion leaders in haute couture, and a remarkable number of creative artists and scientists flourished under a relaxed political system.

During this period, women, now more fully engaged in work outside the home, agitated for the right to vote—efforts that were successful in the United States by 1920. Technological advances made mass production of clothing possible, and ready-to-wear could be bought in large department stores or by mail order. The automobile industry boomed.

World War I shattered the peace when it erupted in Europe in 1914. The war influenced styles of clothing in Europe and America in a number of ways, the most prominent being a move by women into more practical clothes, and shortages of fabrics and certain dyestuffs for coloring.

SUMMARY OF THEMES

SOCIETY	Women's increased entry into the workforce probably helps to establish styles that are shorter, less confining, and more practical.
ECONOMICS	Mail-order catalogs make fashionable clothing available in rural regions.
POLITICS	• World War I influences the cuts and colors of both men's and women's clothing, which pick up military styles. • Garments such as trench coats, sweaters, and jackets that had been part of military clothing carry over into civilian use after the war.
GLOBALIZATION	Asian dress influences specific styles.
TECHNOLOGY	• Ready-to-wear clothing becomes increasingly available, owing in part to manufacturing changes. • Motion pictures, a new medium of communication, spread styles and add to sources of information about costume. • The increasing use of automobiles helps to establish less-confining and more practical styles for women.
FASHION	• Costume becomes related to the work of individual designers such as Paul Poiret and Mariano Fortuny. • Rapid fashion change is seen in women's clothing; men's styles stay relatively stable.

Circle or write in your answers as needed.

Look carefully at the images, then answer the questions that follow.

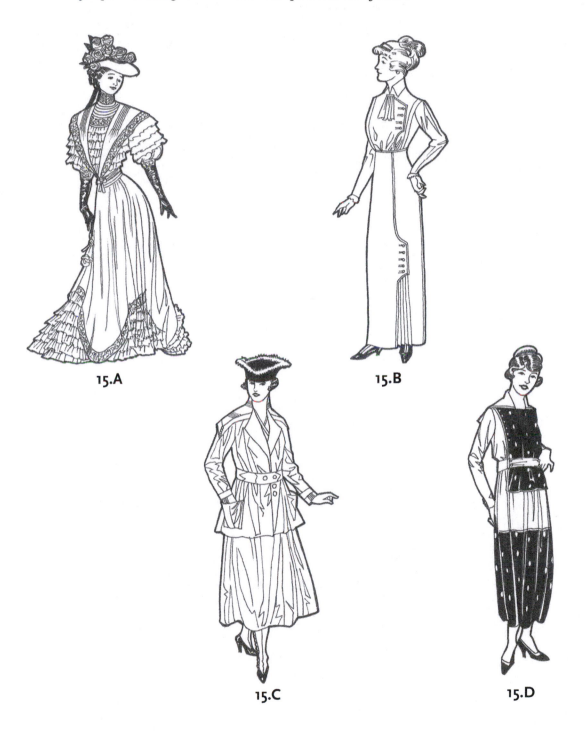

15.A

15.B

15.C

15.D

1. Place Figures 15.A, 15.B, 15.C, and 15.D in chronological order from earliest to latest.

2. Figure 15.A wears an S-shaped silhouette that was often called a:
 a. lingerie dress
 b. pouter pigeon
 c. robe de style
 d. Eisenhower jacket
 e. flapper look

3. The empire style revival is shown in:
 a. Figure 15.A
 b. Figure 15.B
 c. Figure 15.C
 d. Figure 15.D

4. This look foreshadows the unfitted waistline popular during the 1920s.
 a. Figure 15.A
 b. Figure 15.B
 c. Figure 15.C
 d. Figure 15.D

5. This designer was known for hobble skirts and silhouettes similar to Figure 15.B.
 a. Paul Poiret
 b. Mariano Fortuny
 c. Gabrielle "Coco" Chanel
 d. King Edward
 e. Jean Lanvin

1. How does the silhouette change from Figure 15.9 to Figure 15.15 in your textbook?

2. Carefully examine Figure 15.14 from your textbook. Sketch or describe at least five elements of dress depicted in this image that could be used in today's fashionable apparel.

3. How do the silhouette, details of cut, and color of Figure 15.19 from your textbook demonstrate the influence of World War I?

4. List the garments and elements of dress shown in Figure 15.23 that are still worn by men today.

5. Using Figure 15.28 in your textbook, describe how the clothing styles of the children reference adult women's styles of the period. What modifications have been made to the children's styles to achieve a more practical garment?

1. What were some specific styles in garments that were influenced by World War I? Why were these styles influenced by the war? (CO 15.4)

2. Who was Paul Poiret? Describe some of the ways he affected fashion. (CO 15.3)

3. How did Fortuny's designs differ from those of his contemporaries? (CO 15.3)

4. What developments in costume do you see as being related to the increased popularity of the automobile? (CO 15.2)

5. Women's dress silhouettes continued to evolve from 1900 to 1918. Describe this evolution, noting what influences from earlier costume periods you see in these changes. (CO 15.1)

6. What societal factors would affect the change in children's clothing from 1900 to 1920 that reflected a trend toward greater practicality? (CO 15.5)

The Twenties, Thirties, and World War II, 1920–1947

CHAPTER OBJECTIVES

After studying this chapter, you will be able to:

16.1 Determine how social events affected women's fashion changes in the 1920s, 1930s, and 1940s.

16.2 Compare and contrast the prevailing silhouettes for men and women from 1920 to 1947.

16.3 List items of dress for men and women influenced by sports, high society, automobiles, motion pictures, and technology.

16.4 Identify the relationship between costume and the work of individual designers.

16.5 Provide examples of the relationship between costume and developments in the fine arts.

KEY COSTUME TERMS

Adrian	ensemble	rayon
bias cut	flapper	robe de style
bobbed	handkerchief skirt	Schiaparelli, Elsa
bobby-soxer	haute couture	slacks
cami-knickers/step-ins/ teddies	L-85 regulations	sportswear
	Mainbocher	Surrealism
Chanel, Gabrielle "Coco"	McCardell, Claire	Trigère, Pauline
dirndl skirt	Norell, Norman	Vionnet, Madeleine
Eisenhower jacket	nylon	zoot suit
English drape suit	Oxford bag	

HISTORIC SNAPSHOT

The twenties were characterized by prosperity, changing social mores, and radical changes in clothing for women that paralleled changes in social roles. Flying took on new importance, and passenger air service was beginning by the end of the decade. In the United States, the chain store took root during this era. Toward the end of the decade, the bubble of 1920s prosperity burst, and the world sank into the period now known as the Great Depression. Although unemployment was widespread, there were still individuals and families who retained their wealth and partook in luxurious lifestyles.

In the western world, World War II began on September 1, 1939, with the German invasion of Poland. When access to French designers was cut off by the war, the fashion press featured American designers. The United States joined the war after the Japanese attack on Pearl Harbor in 1941. To support the war effort, scarce goods were rationed, and guidelines called the L-85 Regulations restricted the quantity of cloth that could be used in clothing. Many fabrics available before the war were in short supply. Women who worked in factory jobs formerly held by men required special kinds of clothing. Beginning with talking pictures in 1927, the popularity of movies skyrocketed, and the film star soon became a major fashion influence.

SUMMARY OF THEMES

SOCIETY	• Women reject patterns of behavior that had confined them to limited roles in society and adopt radically shorter skirts, cropped hair, cosmetic use, and traditionally masculine garments such as trousers. • Men enjoy a broader range of leisure styles. However, male office workers are still confined to a suit with vest, white shirt, and necktie and male laborers to sturdy, washable work clothes.
ECONOMICS	Clothing styles contrast almost as sharply as economic trends, with the lavish, beaded gowns of the prosperous 1920s giving way to the simpler, more subdued lines of the economically depressed 1930s.
POLITICS	• World War II removes nylon from the consumer market, cuts off supplies of silk from East Asia, and leads to restrictions on the cut of clothing. • The war brings U.S. designers to the forefront of fashion, as the Germans occupy Paris.
CROSS-CULTURAL INFLUENCES	At all levels, the American fashion industry copies European designers Gabrielle "Coco" Chanel, Madeleine Vionnet, and Elsa Schiaparelli.
TECHNOLOGY	New fibers become available; rayon is used throughout the period, and nylon is introduced just before World War II.
ARTS	• Art Deco design motifs appear on textiles of the 1920s. • Italian designer Elsa Schiaparelli incorporates surrealistic elements in her designs.

Circle or write in your answers as needed.

Look carefully at the images, then answer the questions that follow.

16.A 16.B 16.C

1. Place Figures 16.A, 16.B, and 16.C in correct chronological order from earliest to most recent.

2. Describe how changing societal perceptions of women's roles affected the fashions depicted in Figure 16.A.

3. Describe how the Great Depression and influence of movie stars influenced the garments seen in Figure 16.B.

4. How will Figure 16.C change once the United States enters World War II?

5. The tubular shape and geometric lines of Figure 16.A are reminiscent of this art movement.

 a. Surrealism

 b. Abstract Expressionism

 c. Art Deco

 d. Art Nouveau

 e. Fauvism

6. The name of the hat worn in Figure 16.A is:

 a. cloche

 b. coif

 c. picture hat

 d. bowler

 e. turban

7. The bias cut that may have been used in Figure 16.B was popularized by this designer.

 a. Gabrielle "Coco" Chanel

 b. Elsa Schiaparelli

 c. Madeleine Vionnet

 d. Claire McCardell

 e. Adrian

VISUAL OR PRIMARY SOURCE ANALYSIS EXERCISES

1. Using Figure 16.11 in your textbook, describe why Claire McCardell has been called "the mother of American sportswear."

2. Compare and contrast the cut and silhouette of Figures 16.18, 16.20, and 16.23 in your textbook.

3. Figure 16.31 shows a suit approved by the U.S. War Productions Board. How do the men's clothes in Figure 16.32 violate the War Productions Board regulations?

4. How could you make the costumes in Figure 16.37 appeal to a child today?

CRITICAL THINKING QUESTIONS

1. Contrast the economic climate of the 1920s with that of the 1930s. Which differences in clothing styles can be attributed to the economic changes? (CO 16.1)

2. Women's costume underwent radical changes during the period 1920 to 1947, with menswear changing more subtly. What societal events influenced the more rapid changes in women's wear as compared to more reserved changes in menswear? (CO 16.1)

3. Summarize the major government-imposed clothing restrictions and rationing for women in the United States during World War II. (CO 16.1)

4. What were some specific items of dress from 1920 to 1930 that showed influences from each of the following: sports, high society, automobiles, motion pictures, and technology? (CO 16.3)

5. Name three influential designers of the Paris couture and three influential American designers and describe one of the major contributions each made to fashion. (CO 16.4)

6. What elements of the Art Deco and Surrealist art movements were borrowed by fashion designers during the 1920s and 1930s? What elements of these art movements would still be relevant today? (CO 16.5)

The New Look: Fashion Conformity Prevails, 1947–1960

CHAPTER OBJECTIVES

After studying this chapter, you will be able to:

17.1 List the major features of the New Look.

17.2 Name the significant garment styles and prevailing silhouettes for the period 1947 to 1960.

17.3 Assess how changes in fabric technology affected the styles of clothing in the 1950s.

17.4 Determine how changes in patterns of social behavior influenced fashions that were popular during this period.

17.5 Compare the features of notable youthful fads during the period.

KEY COSTUME TERMS

A-line	Dior, Christian	permanent press
baby boom	drip-dry	silent generation
Balenciaga, Cristobal	foundation garment	sneakers
beatnik	gray flannel suit	sweater twin set
bikini	knock-off	Teddy Boy
Bold Look	New Look	wash-and-wear
continental suit	pedal pushers	

HISTORIC SNAPSHOT

In 1947, after World War II, Parisian fashion turned in dramatic new directions that the fashion press labelled "The New Look." These styles dominated fashion design until the mid-1950s, when some silhouette changes began to appear.

Despite prevailing conformity, the beatnik movement was a precursor of some of the youthful protest movements of the 1960s. In the United States, during the Eisenhower administration, the issue of civil rights came to the fore, and in 1954, the Supreme Court overturned the doctrine of "separate but equal" in public education. Despite a series of decisions over the next few years striking down segregation laws, by 1960 only limited progress had been made in ending segregation in the United States. This period saw the rapid development of air travel and the transition from national to globally interdependent economies.

SUMMARY OF THEMES

SOCIETY	More Americans move to the suburbs, where their clothing needs change, along with their lifestyles.Adolescence emerges as an identified stage of development between childhood and adulthood.Teddy Boys and the beatniks use dress to set themselves apart from and, at the same time, express dissatisfaction with the broader society.
ECONOMICS	Adolescent purchasing power grows, allowing this group to acquire popular fad items.French couture designers strongly influence the production and acquisition of textiles, as well-to-do women and celebrities patronize the couturiers and slightly less-affluent American women buy line-for-line copies of Paris designs from retail stores.
POLITICS	Americans fight Communism in the Cold War and racism in the Civil Rights movement.
CROSS-CULTURAL INFLUENCES	The establishment of fashion design centers in major European cities reflects a growing internationalism in fashion.Christian Dior introduces the New Look, which signals a sharp change in women's fashion. For a decade the silhouette of women's clothing follows the pattern established by Dior in 1947.
TECHNOLOGY	Television spreads fashion information rapidly.A host of new fibers become available for use in clothing.
ART/FASHION	As early as the mid-1950s, Balenciaga and Dior show some unfitted dress styles as part of their collections. By the end of the decade, straight, shorter dresses begin to appear in retail stores but meet with little success; possibly they are too radical a departure from established, figure-hugging shapes.

Circle or write in your answers as needed.

Look carefully at the images, then answer the questions that follow.

17.A

17.B

17.C

17.D

1. Place Figures 17.A and 17.B in correct chronological order from earliest to latest.

2. Place Figures 17.C and 17.D in correct chronological order from earliest to latest.

3. Figure 17.A was based on the Edwardian styles of the Teddy Boys.

 true

 false

4. Figure 17.B is an example of a double-breasted, full-shoulder-line look.

 true

 false

5. The name of the silhouette in Figure 17.C is:

 a. A-line

 b. trapeze dress

 c. beatnik

 d. New Look

 e. ballet length

6. The fashion designer who popularized the silhouette in Figure 17.C is:

 a. Dior

 b. Balenciaga

 c. Chanel

 d. Cardin

 e. Fath

7. Garments as shown in Figure 16.D were easier to care for than pre-war styles because of the innovation and adoption of wash-and-wear fabrics.

 true

 false

1. Using proper costume terminology, create a new caption for Figure 17.3 in your textbook.

2. Figure 17.11 suggests items to be included in packing for a weekend in the country. Which looks would still be fashionable today? How would you update the garments to fit into 21st-century lifestyles?

3. Figure 17.17 shows unfitted silhouettes created by fashion designers Dior and Balenciaga. Research (online or in print) present-day garments inspired by these looks.

4. What are the major differences in the three suit styles depicted in Figure 17.22 in your textbook?

5. Define sportswear during the period discussed in Chapter 17. What elements of sportswear as depicted in Figure 17.23 would be fashionable today?

CRITICAL THINKING QUESTIONS

1. What are a few of the major style features of the New Look? How does the New Look compare with styles from the World War II period? (CO 17.1)

2. How do development of beatnik and Teddy Boy styles relate to social issues of the period? (CO 17.5)

3. What were some of the changes in textile technology that affected clothing styles in the early 1950s? How did those changes affect styles? (CO 17.3)

4. Describe television's influence on fashion in its early years. What age group would have been most influenced by fashions seen on television? (CO 17.4)

5. Describe the major changes in men's suit styles from the immediate post–World War II period until 1960. (CO 17.2)

6. How did changes in social behavior influence popular fashions during this period? (CO 17.4)

The Sixties and Seventies: Style Tribes Emerge, 1960–1980

CHAPTER OBJECTIVES

After studying this chapter, you will be able to:

18.1 Name the significant garment styles and prevailing silhouettes for the period 1960 to 1980.
18.2 Identify how social movements in favor of civil rights and feminism and against the Vietnam War contributed to mainstream fashion.
18.3 Explain the ways that fashion reflected current events in politics, space exploration, and the arts from 1960 to 1980.
18.4 Identify the names and contributions of influential designers of the period.

KEY COSTUME TERMS

body suit	leisure suit	pop art
bottom-up theory	licensing	prêt-à-porter
dashikis	maxi skirt	punk styles
designer jeans	midi skirt	rocker
geometric cut	mini skirt	street styles
granny dress	mod	style tribes
hip huggers	op art	trickle-down theory
hot pants	paper dress	wearable art
kente cloth	Peacock Revolution	wedge

HISTORIC SNAPSHOT

By the mid-1960s, the European Economic Community (EEC) had created a single market for its economic resources. In contrast, the Soviet Union continued to keep tight control over its satellite states in Eastern Europe. Other notable events of this period include Algerian independence from France in 1962, the assassination of President

John F. Kennedy in 1963, the start of the U.S. war in Vietnam in 1965, the assassination of Martin Luther King, Jr. in 1968, the first moon landing in 1969, the National Environmental Policy Act of 1970, the thaw in U.S. relations with China and President Richard M. Nixon's visit to Beijing in 1972, the 1973 Arab–Israeli "Yom Kippur" war, the Watergate scandal and Nixon's resignation in 1974, and the emergence of Japan as an economic power. Social protests in the United States grew out of movements protesting the Vietnam War, supporting civil rights and women's rights, and expressing environmental concerns.

The concept of "style tribes," groups that followed styles that diverged from mainstream fashion, emerged in this period. Although the notion of using dress to proclaim an ideology or membership in a specific group obviously did not originate in this period, the tendency for young people to identify with a specific group and set themselves apart greatly accelerated. Hippies, mods, and punks were among the earliest of these groups. It was during this period that jeans became a fashion item, and there was greater acceptance of similar garments for men and women.

SUMMARY OF THEMES

SOCIETY	The Civil Rights movement, student unrest, women's liberation, and growing dissent over the Vietnam War foster changes in fashion that contrast markedly with the 1950s. Skirts come to be shorter than ever. Trousers for women are accepted for daytime and evening wear. Some young men grow shoulder-length hair for the first time in almost 200 years. Men wear more colorful and varied clothing for business and leisure.
ECONOMICS	• Radical changes in attitudes toward fashion indicate profound changes in the organization of the systems for originating, producing, and merchandising fashionable clothing in the decades to come. • Japan's economic model sets the pace for other industrialized nations.
POLITICS	Politics influence fashions when the young and popular Kennedy family enters the White House.
CROSS-CULTURAL INFLUENCES	The Nehru style gains notice in 1966 when French designer Pierre Cardin begins to wear gray flannel suits with Indian-style jackets upon returning from a trip to India.
TECHNOLOGY	• Advances in technology for manufacturing nylon stockings make it possible to construct seamless stockings, and pantyhose gain wide acceptance. • Americans make the first manned moon landing in 1969, and designers use materials inspired by astronauts' needs in space.

Circle or write in your answers as needed.

Look carefully at the images, then answer the questions that follow.

18.A 18.B 18.C 18.D

1. The greater variety in menswear as shown in Figure 18.A was influenced by this group.

 a. mods

 b. punks

 c. beatniks

 d. Civil Rights protestors

 e. Teddy Boys

2. The name of the suit jacket in Figure 18.A is:

 a. leisure suit

 b. Nehru jacket

 c. body shirt

 d. zoot suit

 e. English drape suit

3. The name for men who adopted the colorful and patterned clothing seen in Figure 18.B was:

 a. pouter-pigeon

 b. Beatles

 c. peacocks

 d. diamonds in the yard

 e. macaronis

4. The short skirt in Figure 18.C was known as the:

 a. miniskirt

 b. maxi skirt

 c. longuette

 d. bikini

 e. pantsuit

5. The art movement that influenced the black-and-white style shown in Figure 18.C was:

 a. Art Nouveau

 b. Art Deco

 c. Surrealism

 d. op art

6. The pantsuit as seen in Figure 18.D was symbolic of changes in women's roles during the time.

 true

 false

7. The widespread adoption of pantsuits as seen in Figure 18.D was seamless and without controversy.

 true

 false

VISUAL OR PRIMARY SOURCE ANALYSIS EXERCISES

1. Name three political, social, and/or cultural occurrences that influenced the look of Figure 18.4 in your textbook.

2. Using Figure 18.6 in your textbook as inspiration, what are some styles today that are unisex? How are details, colors, and silhouettes modified to indicate a male or female wearer?

3. What elements of the styles worn by Jacqueline Kennedy as depicted in Figure 18.8 are considered timeless and classic today?

4. Compare and contrast the styles shown in Figure 18.25 and 18.26.

5. Using correct costume terminology, describe the men's garments in Figure 18.29.

1. What overall trends in men's clothing styles can be attributed to the influence of the mods and the hippies? (CO 18.1)

2. Describe how jeans came to be a high-fashion item. How could jeans be used to illustrate the bottom-up theory of fashion change? (CO 18.1)

3. What were some of the fashions that emerged at the time of the Civil Rights movement of the 1960s? What were the motivations that led many African Americans to adopt these styles? To what extent did these styles become part of mainstream fashion? (CO 18.2)

4. What effect did the movement for women's rights have on fashion? Identify some of the resulting style changes that have survived. (CO 18.2)

5. What are some of the ways that current events in politics, space exploration, and the arts were reflected in fashions from 1960 to 1980? (CO 18.3)

6. Of the fashion designers listed in Chapter 18, which five do you consider still influential today? Why? (CO 18.4)

The Eighties and the Nineties: Fragmentation of Fashion, 1980–1999

CHAPTER OBJECTIVES

After studying this chapter, you will be able to:

19.1 Identify how social, economic, and political events including the energy crisis, animal rights activism, and changes in the roles of women contributed to mainstream fashion during the 1980s and 1990s.

19.2 Describe changes in the fashion industry during this time.

19.3 Identify the names and contributions of influential designers of the period.

19.4 Summarize how street styles influenced mainstream fashion.

19.5 Evaluate the ways in which fashion became more fragmented.

KEY COSTUME TERMS

bridge lines	heroin chic	preppy
casual Friday	kiddie couture	quick response
conspicuous outrage	le pouf	retro
cosplay	mass customization	shorts suit
dreadlocks	microfibers	unisex clothing
fashionista	minimalist	
generation X	power suit	

HISTORIC SNAPSHOT

The Berlin Wall fell in 1989 and East and West Germany were reunited in 1990. The Soviet government collapsed in 1991, officially bringing the Cold War to an end, and the Russian Republic was born. The European Community continued to develop and expand its functions. In Asia, Japanese economic power and political influence continued to grow. Japanese competition in automobiles and electronics forced U.S. producers to cut their payrolls and introduce new technologies. In the 1990s, however, the Japanese

economy suffered deflation, lowering consumer prices and wages and forcing a transformation in parts of that country's economy. Nevertheless, Japan continued to be a leader in both luxury fashion and ready-to-wear. In the United States, notable foreign policy events include the invasion of Panama, the Persian Gulf War, and the passage of the North American Free Trade Agreement (NAFTA).

The AIDS epidemic was felt in the fashion world with the loss of a number of designers and other professionals. Women's professional successes led some to adopt "power suits." The development and use of computers and the Internet affected numerous facets of business, industry, education, and personal life. The effect of the Internet can be seen in the design and manufacture of clothing, merchandising, and distribution. It has made possible the globalization of the fashion industry. Also during this period, the need to decrease carbon dioxide emissions became recognized internationally, and consumer support for environmentally sound products increased. Almost every social, economic, political, and art trend could be seen to have some connections with fashion.

SUMMARY OF THEMES

SOCIETY	• Conformity to the predominant silhouette and skirt length as a mark of sophistication disappears. • Common threads, such as hemlines and fabrics, tie together clothing for all ages and both sexes.
ECONOMICS	• GATT and NAFTA treaties affect the American apparel industry. • Specialized retail outlets proliferate, and consumers are accustomed to having a wide variety of fashion goods from which to choose. Entrepreneurs in the fashion industry must satisfy the preferences of their customers if they wish to survive.
POLITICS	• Political leaders and their families, such as Nancy Reagan and Princess Diana, influence style. • Conflicts such as the first Persian Gulf War, Somalia, Bosnia, Afghanistan, and Iraq yield styles with military influences.
CROSS-CULTURAL INFLUENCES	The fashion industry develops a structure and a means of production and distribution reliant on customers who follow the latest major trends from the international style centers. A more diverse, more segmented marketplace replaces the fashion industry that once spoke with a single voice.
TECHNOLOGY	New computer-based technologies enable manufacturers to adapt more rapidly to style changes.
ART	Media influences such fashions as the western styles of the 1970s, designs inspired by the film *The Great Gatsby* in 1974, Japanese designer ideas from around 1980, and retro fashions seen from the 1980s and 1990s.
FASHION	• Fashion periods last 10 years or less. • World-class designers in Paris and other fashion centers create extreme designs.

Circle or write in your answers as needed.

Look carefully at the images, then answer the questions that follow.

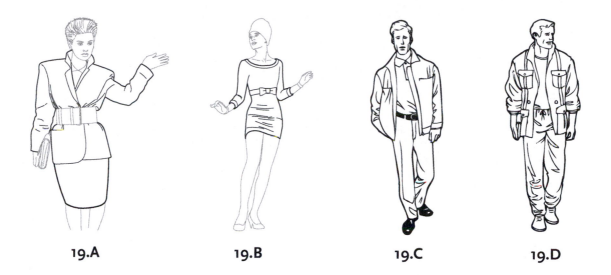

19.A 19.B 19.C 19.D

1. The wide, padded shoulders and shorter skirts as seen in Figure 19.A were popular during the 1980s.

 true

 false

2. The power suit look of Figure 19.A was often called "dress for success."

 true

 false

3. This fiber contributed to the tight, close fit of garments as seen in Figure 19.B.

 a. polyester

 b. rayon

 c. cotton

 d. spandex

 e. lyocell

4. From which decade does the retro look of Figure 19.B derive?

 a. 1900s

 b. 1930s

 c. 1940s

 d. 1960s

 e. 1970s

5. Explain how the casual look of Figure 19.C may be related to the changing demographics of the 1990s.

6. The attire in Figure 19.C would not have been appropriate office wear in the 1990s.

 true

 false

7. The emphasis on fitness made activewear as seen in Figure 19.D an important part of men's wardrobes.

 true

 false

1. Compare and contrast the garments of the style tribes as depicted in Figure 19.11 in your textbook. How do the garment choices communicate the group's passions and interests?

2. What changes to Figure 19.15 in your textbook would make it acceptable for the ready-to-wear market?

3. Compare and contrast the silhouette and likely fiber and fabric choices as seen in Figures 19.29 and 19.30.

4. What elements of dress in Figure 19.33 would remain fashionable today?

5. Create a new caption for Figure 19.38 using correct costume terminology.

CRITICAL THINKING QUESTIONS

1. In what ways did changes in women's social and economic roles from 1980 to 1999 affect fashions during this same period? (CO 19.1)

2. What examples can you give of street styles influencing fashions in the 1980s and 1990s? (CO 19.4)

3. Describe the relationship between the French haute couture and the prêt-à-porter as it existed in the 1990s. What part did each of these play in the origin and distribution of fashionable clothes? (CO 19.2 and 19.3)

4. When did Japanese fashion designers gain international prominence? List a few characteristics of these designers' work and describe the effect that they had on fashion trends of that time and today. (CO 19.3)

5. What were changes made in the fashion industry during the 1980s and 1990s and how did these influence fashions of the periods? (CO 19.2 and CO 19.5)

The New Millennium, 2000–2014

CHAPTER OBJECTIVES

After studying this chapter, you will be able to:

20.1 Describe how changing U.S. demographics affect the fashion industry.
20.2 Identify how the Internet has changed the ways in which fashion is sold and consumed.
20.3 Discuss how current events influence the adoption of specific garments.
20.4 Explain how technology has affected fashion in the new millennium.

KEY COSTUME TERMS

avatar	Crocs	social networking site
boho	hijab	soul patch
burqini	hoodie	Tencel
capri	multichannel retailing	trucker's cap
cargo pants	pashmina	

HISTORIC SNAPSHOT

The September 11, 2001, attacks on the United States had a far-reaching impact. The ensuing conflicts in the Middle East influenced both domestic and international politics. In fashion, the variety of styles available for women, men, and children flourished with a multitude of sources including designers, celebrities, and Internet blogs and

videos. Although apparel conglomerations and mergers increased, niche producers also succeeded, particularly in ethnic and plus-size markets. Technological innovations moved fiber and fabric performance forward, while designers found inspiration for silhouettes in the previous century.

SUMMARY OF THEMES

SOCIETY	Dress is increasingly segmented according to age, class, ethnicity, occupation, recreational preference, and musical taste. The fashion press and other media, such as personal blogs, facilitate the movement of specific fashions from one segment of society to another.
ECONOMICS	The Great Recession influences personal spending on clothing.
POLITICS	• American flags appear on clothing following the September 11, 2001 tragedy. • First Lady Michelle Obama and the Duchess of Cambridge have stylistic influence.
CROSS-CULTURAL INFLUENCES	The global fashion industry includes collaborations from designers, manufacturers, merchandisers, and retailers from all over the world.
TECHNOLOGY	• Innovations in the functionality of clothing yield garments that perform more tasks than mere aesthetics. • The Internet plays a powerful role in the acquisition and promotion of clothing.
ART	Exhibitions of fashion in fine art museums become commonplace.

Circle or write in your answers as needed.

Look carefully at the images, then answer the questions that follow.

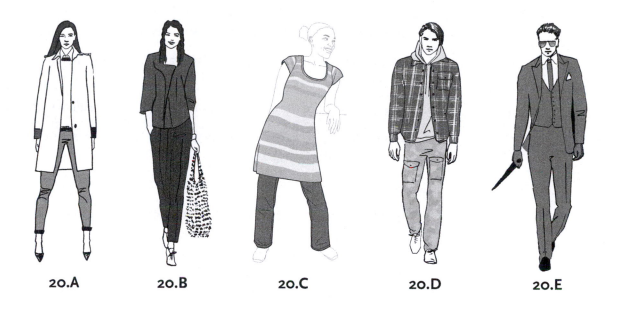

20.A 20.B 20.C 20.D 20.E

1. Figure 20.A is a demonstration of the mixing of levels of formality and colors, textures, and patterns common during the 2000s.

 true

 false

2. Pantsuits as seen in Figure 20.B were rarely accepted as appropriate business wear for women in the 2000s.

 true

 false

3. Explain how the denim jeans shown in Figure 20.C are an example of "world dress."

4. Which statement is *not* true about denim jeans in the 2000s?

 a. Denim jeans were worn for casual wear and even for some business and formal occasions.

 b. Denim jeans were worn by men, women, and children all over the world.

 c. Denim jean styles were available in dark and light washes, diverse colors, plain designs, or embellishments.

 d. Denim jeans were reserved for the college age group.

 e. Even high-fashion designers show denim jeans in their collections.

5. The large cargo pockets on Figure 20.D were popular, in part because they made a convenient storage place for cell phones, which had become ubiquitous.

 true

 false

6. Political events of the 2000s influenced the adoption of which styles?

 a. cargo pants

 b. trench coats

 c. decorative motif of the American flag

 d. camouflage

 e. all of the above

7. The dressed-up look of Figure 20.E coexisted with more casual styles for menswear.

 true

 false

1. Using Figure 20.6 from your textbook as inspiration, describe how the Internet has affected your shopping habits.

2. Using Figure 20.12 as inspiration, find five examples of message T-shirts as worn by people in your community.

3. What changes would you make to Figure 20.17 to make it look more formal? Less formal?

4. Compare and contrast Figures 20.30 and 20.31 in your textbook.

5. Using online or print resources, create your own Modern Influences table of images that correspond to Parts 1, 2, 3, 4, 5, and 6 of the textbook.

CRITICAL THINKING QUESTIONS

1. Describe how changing demographics such as the increase in the Hispanic population and the proportion of plus-sized individuals affected the fashion industry. (CO 20.1)

2. How has the Internet, particularly fashion blogs, avatars, and social media, changed the ways fashion is marketed to consumers and how it is purchased by consumers? (CO 20.2)

3. Current events affect fashion. List at least three events that occurred in the 2000s and detail how these events influenced the adoption of specific styles. (CO 20.3)

4. Technology has had a profound effect on the ways in which we live our lives. How does technology affect you? (CO 20.4)

5. How can you use the history of dress to meet your future career goals?

COATS AND JACKETS

Chesterfield coat

flight jacket

Norfolk jacket

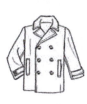

pea jacket

polo coat

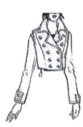

spencer jacket

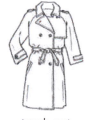

trench coat

CONSTRUCTION DETAILS

gusset

handkerchief hem

blouson dress

bouffant dress

bubble dress

bustle dress

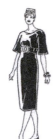

chemise dress

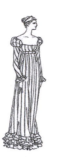

empire-style waist

princess-style dress

shirtwaist dress

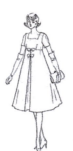

trapeze dress

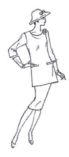

tunic dress

bateau neckline

bertha neckline

cowl neckline

funnel neckline

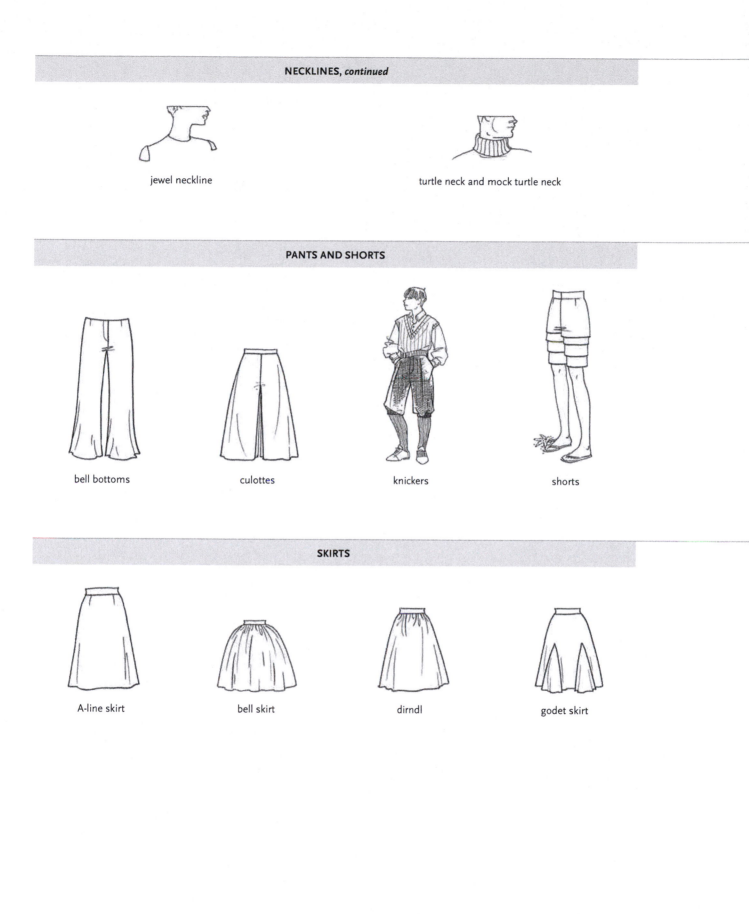

jewel neckline

turtle neck and mock turtle neck

PANTS AND SHORTS

bell bottoms

culottes

knickers

shorts

SKIRTS

A-line skirt

bell skirt

dirndl

godet skirt

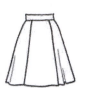

gored skirt

hobble skirt

peg-top skirt

trumpet skirt

SLEEVES

bell sleeve

bishop sleeve

cap sleeve

cape sleeve

dolman/batwing sleeve

kimono sleeve

leg-of-mutton sleeve

raglan sleeve

argyle sweater

cardigan sweater

OTHER TERMS TO KNOW

glove

New Look

peplum

pinafore

smock

tuxedo

Watteau back

GLOSSARY

As space does not permit an entry for every prominent fashion designer, students are referred to the designer tables in Part 6 of the textbook for information about individuals not included here.

#s

501 jeans Jeans manufactured by Levi Strauss; the number 501 was the lot number given to jeans in 1890 by the manufacturer

A

abolla A cloak made from a folded rectangle fastening on the right shoulder that distinguished officers from ordinary soldiers in ancient Rome

acetate Generic category for fibers manufactured from cellulose materials such as wood chips; characterized by a crisp hand and a high luster

Aesthetic Movement A popularized form of pre-Raphaelite philosophy (see *pre-Raphaelite*) that attracted painters, designers, craftsman, poets, and writers

afiche A round brooch from the Early Middle Ages used to close the top of the outer tunic, bliaut, or surcote; also called *fermail*

afro A hairstyle first adopted by African Americans in the 1960s in which hair that has a natural tight curl is allowed to assume its natural shape

aiguillettes Small, jeweled metal points used as fasteners

à la Chinoise Women's hairstyle of the Romantic Period, created by pulling back and side hair into a knot at the top of the head, while hair at the forehead and temples was arranged in curls

à la Titus Women's short hairstyle of the Empire Period; similar to that on busts of the Ancient Roman emperor Titus

à la victime Short women's hairstyle of the Empire Period similar to the haircut given to women who were to be guillotined

alb A long, white, early medieval tunic worn by priests; had narrow sleeves and a slit for the head, and was tied with a belt

A-line A style of dresses or skirts, introduced in the 1950s and 1960s, that is fitted at the top and flares wider and unfitted toward the bottom, with a shape similar to the letter A

amice A strip of linen placed around the shoulders and tied in position to form a collar; worn by priests saying mass in the early Middle Ages

amictus Roman name for garments that were wrapped around the body; those that were "put on" were called *indutus*

amulet Charm worn around the neck to ward off evil

anakalypteria Ritual unveiling of a bride in ancient Greece

Anglomania In the 18th century, a French fad for English things

anime Japanese animation

artificial silk Term used before 1925 to describe rayon and acetate; also called *art silk*

Art Nouveau In the late 18th and early 19th centuries, a movement in which artists and artisans attempted to develop a style having no roots in earlier artistic forms; characterized by sinuous, curved lines, contorted natural forms, and a sense of movement

ascot Tie with wide ends that was worn with one end looped over the other and held in place with a tie pin

athletic shirt Man's sleeveless undershirt with low, round neckline; also worn for athletic events; also called *tank top*

avatar A character representing oneself

B

baby boomers The 76 million Americans born between 1946 and 1964

bagpipe sleeve Sleeve style used during the Late Middle Ages that widened from the shoulder to form a full, hanging pouch below a tight cuff

Balagny cloak Circular cape of the 17th century, which hung over one shoulder, often secured with a cord that passed under the wide collar

ballerina length Dresses or skirts with hemline placement at mid-calf

balteus Ancient Roman toga style in which the section under the right arm was brought higher and the top twisted into a sort of belt-like band, eliminating the *umbo*

band See *falling band*

band collar Collar appearing in fashions of the early 2000s that stands up around the neck and may close with buttons at the front or back

banyan Comfortable, loose-fitting, often very decorative dressing gown from the 18th century worn by men for indoor and outdoor use

barbette A woman's headdress used during the Early Middle Ages, consisting of a linen cloth that stretched down from the temple, under the chin, and up to the other side of the head, and was worn with a *fillet*

barege An attractive silk and wool blended fabric, relatively sheer, crisp, and lightweight; popular in the 19th century

Baroque style Artistic style from the end of the 16th century to the middle of the 18th century; emphasized lavish ornamentation, free and flowing lines, and flat and curved forms

bases Separate short skirts worn with a jacket or doublet for civilian dress, or over armor for military dress; made from a series of lined and stiffened gores; persisted in civilian dress well into the mid-16th century, and over armor for even longer

basque The extension of a doublet or bodice to below the waistline. After the 17th century basques were largely a feature of women's dress in the 19th and early 20th centuries.

basque shirt Striped, wide crew-necked shirt popular in the 1930s

battle jacket Waist-length army jacket worn in World War II with two breast pockets, fitted waistband, zippered fly closing, and turn-down collar with revers; also called *Eisenhower jacket*

batwing sleeve Long-sleeve cut with deep armhole extending almost to the waist and tight at the wrist, creating a winglike appearance; a variation of the *dolman sleeve*

bavolet A ruffle at the back of the neck of a bonnet to keep the sun off the neck

Bayeux Tapestry An embroidered wall hanging from the late 11th century that was one of the earliest and most important sources of information about the appearance of medieval armor; depicts the events leading to the Battle of Hastings, which took place in 1066

bead net dress Ancient Egyptian women's overdress made of beads held on netting that may have been worn over sheath dresses

beatniks Social group that first appeared in the latter part of the 1950s; characterized by eccentric habits of dress and grooming, including beards, ponytails, and

black clothes, especially turtlenecks and berets for men and leotards, tights, and ballet slippers for women

bed hair Tousled hair

bergere Large, flat straw hat from the 18th century with low crown and wide brim that sometimes tied under the chin; also known as a *shepherdess hat*

bertha Wide, deep, cape-like collar placed at the neckline of women's dresses or blouses

bezants A vertical line of decorative brooches or jewel-like ornaments stamped from gold, placed on the front of the placard

bias cut A technique for cutting clothing to utilize the diagonal direction of the cloth, which has greater stretch and interesting draping qualities

bicorne Name given by costume historians to an 18th-century hat in the shape of a crescent, with the front and back brims pressed against each other, making points on either side

biggin Child's cap similar to a medieval coif

bikini Two-piece swimsuit introduced in 1946 by designer Jacques Heim; named for Bikini Island, where atomic weapons were tested, because it was said to be "smaller than an atom"

birrus A cloak resembling a modern, hooded poncho, cut full and with an opening through which the head was slipped; used in ancient Rome; also spelled *burrus*

bishop sleeve Made with a row of vertical pleats at the shoulder that released into a soft, full sleeve gathered to a fitted cuff at the wrist; popular until 1840 during the Edwardian Period. After this the term referred to a sleeve gathered into the *armscye* (armhole) and full below the elbow with fabric puffed or pouched at the wrist.

blazer In the 19th century, referred to a single-breasted sport jacket in a solid color or striped; now made in many colors, as well as with varying types of pockets; generally worn with contrasting trousers

bliaut Tightly fitted one-piece garment worn in the 12th century

bliaut gironé A close-fitting garment made with an upper section joined to a skirt. A style worn by men and women during the 12th century.

bloomer dress Pants with full legs gathered to fit tightly at the ankle; worn under short skirts to create the "bloomer" costume, which was developed by American feminists in the late 19th century to reform women's clothes of the period, which they saw as confining and impractical. Bloomers were named after Amelia Bloomer, who endorsed the style, wrote favorably about it in 1851 in a journal she edited, and wore it for lectures.

blue jeans See *Levi's*

blue war crown Worn by Egyptian pharaohs to symbolize military power or when going to war; made of molded leather and decorated with gold sequins with a *uraeus* at the center front

bob 1920s slang for short blunt-cut hair, either with bangs or bare forehead

bobbin lace A complex textile originating in the last half of the 16th century; created by twisting or knotting together linen, silk, or cotton held on threads held on bobbins. Also called *pillow lace* because during its production the lace was held in place with pins set in a pillow.

bobby pin Small flexible piece of metal bent in half with prongs held together by the spring of the metal; worn to keep hair in place or to set hair in pin curls; first appeared in the 1920s

bobby-soxers Slang for teenagers of the 1940s who followed current fashion fads such as bobby socks and saddle shoes

body jewelry Highly decorative accessories that may be attached to body piercings. Includes elaborate metal jewelry and decorative chains designed to be worn on the body, face, and head and over stockings or clothing; became popular in the 1990s.

body shirts Shirts for men fitted by shaping side seams to conform to body lines; introduced in the early 1960s

body stockings Body-length, knitted stretch underwear for women; introduced in the early 1960s

body suits Body-length, knitted stretch underwear for women that usually ended at the top of the leg; usually worn with the upper section visible as a blouse

boho Derived from the term "bohemian"; a style from the early 2000s characterized by vibrant colors, softly flowing fabrics, and combinations of variously patterned fabrics, in part a revival of upscale hippie-influenced clothes of the 1960s

Bold Look Term introduced for men in October 1948; not a radical change in fashion, but rather a continuation of the English drape cut with greater emphasis on coordination between shirt and accessories and the suit

bombast Stuffing made of wool, horsehair, short linen fibers called tow, or bran; used to pad trunk hose and doublets in the 16th century

bonnet rouge A soft woolen peasant's cap of a red color that became a symbol of the French Revolution

boot cuffs Wide cuffs on sleeves of suit coats that, when folded back, reached the elbow; popular in the early 18th century

bottom-up theory of fashion The idea that some fashion changes result from older or more affluent individuals adopting styles that originated with groups or individuals who are young, less affluent, or from the counterculture; see also *trickle-down theory of fashion*

bowl crop Hairstyle used during the Late Middle Ages that gives the appearance of an inverted bowl around the top of the head

bowler British term for a hat from the 1840s and 1850s and after with a stiff, round, bowl-shaped crown and a narrow brim; in the United States the style is called a *derby*

box coat See *curricle coat*

boxer shorts Underwear introduced in the 1930s; style inspired by professional boxers

braces British term for suspenders

braies Undergarment consisting of loose-fitting linen breeches, used in the 10th and 11th centuries; fastened at the waist with a belt

brassiere A basic item of underwear to support adult women's breasts; the bust supporter of the 1890s was modified to make it more suitable for supporting the fashionable silhouette of the early 1900s; the term continues in use, although specific details of its structure changed in different periods

breeches General term referring to any of a variety of garments worn by men to cover the lower part of the body; first appeared in the Middle Ages

breeching A ritual carried out in Renaissance England when a boy of age 5 or 6 was given his first pair of breeches

bridge lines Lines at the upper end of the apparel price range and made with fewer details and less expensive fabrics than designer clothing; appealed particularly to executive women

briefs Tight-fitting, short, knitted underpants worn by men and boys; also women's or girls' very short underwear, sometimes made of control stretch fabric with garters added

bulla Locket made of gold, silver, bronze, or leather that contained charms against the evil eye for a free-born boy of ancient Rome; placed around the infant's neck at the time of naming

bum roll Padded roll placed around the waist in order to give skirts greater width below the waist; popular in the late 16th century

burnous A large mantle of about three-quarter length with a hood; popular women's garment in the early 19th century; the name and style were derived from a similar garment worn by Arabs who lived in the Middle Eastern deserts

burqini Bathing dress worn by some Muslim women that covers all of the body except the face; usually consists of a knee-length, long-sleeved tunic, over long trousers and a headscarf.

burrus See *birrus*

bush jacket Jacket made of khaki-colored cotton with peaked lapels, single-breasted front, belt, and four large bellows pockets; originally worn on hunting expeditions in Africa in the early 20th century

busk A device made from a long, flat piece of wood or whalebone that was sewn into one or more casings in corsets of the early 16th century

bustle During the Romantic Period, referred to small down-filled or cotton-filled pads worn by women that tied on around the waist at the back and held out skirts in the back; by the Bustle Period, referred to any number of supports added to create full backs of skirts. From 1870 to 1878, a full bustle was created by manipulation of the drapery at the back of the skirt; from 1878 to 1883, the narrow, cuirass bodice was used, fullness dropped to below the hips, and a semicircular frame supported the trailing skirts; and from 1884 to 1890, large, rigid, shelf-like bustles were used.

byrnie See *hauberk*

C

cabochon stones Stones cut in convex form but without facets, used in jewelry

cage crinoline See *crinoline*

calash An 18th-century hood made large enough to cover the hair, made of a series of semi-hoops sewn into the hood at intervals in order not to crush the hair; when not being worn it folded flat

calasiris See *kalasiris*

caleche See *calash*

calico Indian printed cotton fabric popularized in England; name first applied to fine-quality, printed cotton fabrics from Calcutta; later came to be generally applied to a wide variety of colorful, printed cotton fabrics of all qualities

California collar Shirt collar from the 1930s that had shorter, wider points than the Barrymore collar of the 1920s

cambric A plain-weave, fine, white linen fabric

camicia The Italian word for a man's shirt and for a woman's chemise; plural *camicie*

cami-knickers A combination of the camisole and panties, worn by women in the 1920s

camisole See *corset cover*

canezou A small, sleeveless spencer jacket worn over a bodice; or a garment synonymous with the pelerine; by the Crinoline Period, became a term applied to a variety of accessories including fichus, muslin jackets worn over bodices, and chemisette neck fillers

canions Extensions from the end of the trunk hose to the knees or slightly below, made in either the same or a contrasting color with the trunk hose or fastened to separate stockings at the bottom; used by men in the late 16th century

canons Full, wide ruffles attached at the bottom of breeches during the mid-17th century

capotain See *copotain*

capote A bonnet with a soft fabric crown and a stiff brim worn by women in the early 19th century

capri pants Tight-fitting, three-quarter-length pant worn by women; first appeared in the late 20th century and revived in the 21st century

caraçao A thigh-length, fitted women's jacket with no waistline that flared below the waist, popular in the late 18th century

cargo pants Pants with large patch pockets, the curved part of which extends to the waist and forms a loop though which the belt is pulled; popular in the late 20th and early 21st centuries

carmagnole A short, dark-colored woolen or cloth jacket that was hip length with fullness at the back, cut rather like a smock; popular during the Directoire Period as part of the "sans culottes" style of the French Revolution

carriage dress A women's dress from the Romantic Period suitable for riding in a carriage; conformed with current styles and was frequently trimmed with fur

carriage parasol A parasol from the Romantic and Crinoline Periods with a folding handle

carrying frocks Long gowns worn in the 17th century by infants who were not yet able to walk

casaque An early 17th century men's coat with wide, full sleeves that were wide throughout the body and ended at the thigh or below

casaquin Thigh-length, fitted women's jacket with no waistline seams that flared below the waist; popular in the early to mid-18th century

cashmere (or kashmir) shawl Shawl made from the soft hair of the cashmere goat, and woven in Kashmir, a northern province on the Indian subcontinent; incorporated a decorative motif thought to derive from the *boteh*, a stylized representation of the growing shoot of the date palm. The first appearance of this shawl in Europe is not certain, but some scholars relate it to the arrival in London in 1765 of a young English woman who had been in Bombay; see also *paisley shawl*.

cassock English term for *casaque*

casual Friday Working days identified by business or industry when employees can wear casual dress to work; for many companies, the selected day is Friday; first began in the late 20th century

casual jacket Men's jacket cut along the lines of a business suit jacket and worn with contrasting fabric trousers; first appeared in the 1920s and is also referred to as a sports jacket

catogan See *club wig*

chainse A distinctive type of outer garment for upper-class women of the 12th century made of washable material, probably linen; long and seems to have been pleated

Chambre Syndicale de la Couture Parisienne An organization of couturiers that is still active in the French haute couture

chameleon fabrics Fabrics that react to external environmental stimuli by changing color reversibly

chapeau bras Men's flat, three-cornered hat, evenly cocked or crescent-shaped, made expressly to be carried under the arm; popular during the early 19th century

chaperon A hood attached to a small cape that sometimes had a decorative tube attached at the back of the head (see *liripipe*); worn in the Middle Ages

Charles Frederick Worth Englishman who emigrated to Paris, where, in the 1850s, he became an internationally known designer of women's fashions and founded what became the haute couture; see *haute couture*

chasuble Evolved from the Roman *paenula*; was given up by the laity, but continued to be worn by early medieval clergy with sides cut shorter to allow movement of the arms

chatelaine Ornamental chains worn by women at the waist from which were suspended useful items such as scissors, thimbles, button hooks, and penknives; popular during the 19th century

chausses Leg protectors made of *mail* (armor made of interlocked metal rings); worn by men in the Early Middle Ages

chemise A loose-fitting linen women's undergarment worn very close to the skin; was much like a man's undershirt, except that it was cut longer; first appeared in the Early Middle Ages

chemise à la reine An 18th-century white muslin gown that resembled the chemise undergarment of the period, but, unlike the chemise, had a waistline and a soft, fully gathered skirt

chemisettes Fillers that raised the necklines of daytime dresses; also known as tuckers

Chesterfield A single- or double-breasted men's coat with no waistline seam, a short vent in the back, no side pleats, and often a velvet collar; popular in the mid-19th century and after

chignon Bun of hair at the back of the neck

chinos Washable man's sport pants made of chino cloth, a durable, close-woven, khaki-colored cotton fabric; first appeared in the 1950s

chintz During the 17th century, referred to hand-painted or printed fabric imported from India that was sometimes glazed; today, generally refers to any printed or dyed cotton-blend fabric with a shiny, glazed surface

chiton Tunic worn by men and women in ancient Greece that consisted of a rectangle of fabric wrapped around the body and fastened at the shoulders with one (*Doric* or *Helenistic chiton*) or more (*Ionic chiton*) pins

chlamydon More complicated form of the woman's diplax used in ancient Greece in which fabric was pleated into a fabric band; see also *diplax*

chlamys Rectangular cloak of leather or wool pinned over the right or left shoulder; worn by men in ancient

Greece over a *chiton*, especially for travelling, when it could also be used as a blanket

chlanis Hand-woven tunic presented to a groom by the bride in ancient Greece, demonstrating her mastery of weaving

chopines Very high platform-soled shoes worn by women throughout Italy and in northern Europe during the Renaissance; soles were especially high in Venice

chukka boots Men's and boy's ankle-high boot laced through two sets of eyelets, made of splits of unlined suede cowhide with a thick crepe-rubber sole; originally worn by polo players and adopted for general wear in the 1950s

circlets Headbands of gold worn by wealthy women in the Early Middle Ages

clavus Broad purple band that extended vertically from hem to hem across the shoulders on the tunic of a Roman senator beginning in Republican times; later, referred to any band decorating a tunic; plural *clavi*

clocks A small design that decorated the sides of white silk stockings in the 1870s and other, later periods

clogs Footwear style popular during the Middle Ages and the Baroque and Rococo Periods; revived during the sixties and seventies and after. Generally made with a raised sole that often served to keep the foot or shoes off the ground.

closed mantles Garments for men in the Early Middle Ages consisting of a length of fabric with a slit through which the head could be slipped

clothes Collective term for all items of apparel worn on the body by men, women, and children

club wig A style of men's wig from the 18th century in which a *queue* (a lock or pigtail at the back), was doubled up on itself and tied to form a loop of hair

coat of plates Solid military armor from the 14th and 15th centuries; the trunk of the body consisted of a cloth or leather garment lined with metal plates

codpiece A pouch of fabric that was sewn into the crotch of hose to accommodate the genitals, make the hose fit properly, and enable men to relieve themselves.

It closed with laces and first appeared during the Late Middle Ages. With added padding it became an obvious feature of men's clothing; went out of use by the 17th century.

coif During the 12th century, referred to a men's cap that tied under the chin and was similar to a modern baby's bonnet in shape; gradually disappeared except in the dress of clergy and professions such as medicine. During the early 16th century, referred to a women's cap of white linen or more decorative fabric, with extensions below the ears that covered the side of the face.

combat shorts Thigh-length shorts with two very large patch pockets in front; worn by men and women; first appeared in the late 20th century

combination A women's undergarment combining the chemise and drawers into one piece; popular during the mid-19th century

commode See *fontange*

conch Sheer, gauzelike veil worn by women in the late 16th century, cut the full length of the body from shoulder to floor and worn cape-like over the shoulders

conque See *conch*

conspicuous consumption Demonstrating affluence through the acquisition of items that display the wealth of the wearer; term coined by economist and sociologist Thorstein Veblen in his 1899 book *The Theory of the Leisure Class*

conspicuous leisure Demonstrating affluence through wearing of encumbering garments in which it would be difficult to do any menial work; term coined by economist and sociologist Thorstein Veblen in his 1899 book *The Theory of the Leisure Class*

conspicuous outrage Demonstrating economic status by making purchases so outrageous that they showed the buyer had money to spend on something nonfunctional or contrary to expectations for "new" and high-priced garments; term coined by Quentin Bell in his 1973 book *On Human Finery*

continental suit Men's suit from the late 1950s with a shorter jacket, a closer fit through the torso, and a rounded, cutaway jacket front

cony Small burrowing rodent; trimmings and linings from conies were reserved for the lower classes during the Late Middle Ages

cope A voluminous cape from the Early Middle Ages worn by the clergy for processions

copotain High-crowned, narrow-brimmed, slightly conical hat worn by men and women in the early 17th century; also called *sugar loaf hat*; sometimes spelled *capotain*

cornette See *liripipe*

corn-row braids A traditional African way of arranging the hair in myriad small braids, worn by women in the 1970s and later worn by both men and women

corselet A sleeveless, probably decorative form of armor used by men in ancient Egypt during the Middle and New Kingdoms; was either strapless or suspended by small straps from the shoulders

corset During the Late Middle Ages, referred to a round cape used by men that buttoned on the right shoulder and left the right arm free or closed at the center with a chain or ribbon. By the 17th century, the term referred to cloth shaped as a bodice that was stiffened, usually with bone, and laced together at front, back, or both and could be used as an under or outer garment; see also *busk* and *stays*. In later periods the construction and shaping changed in order to enable the wearer to conform to the fashionable silhouette.

corset cover During the Crinoline Period, a waist-length garment that buttoned down the front and shaped to the figure, with short sleeves; also known as a *camisole*

cosplay Term from Japan to used to describe the practice of dressing up as the characters from Japanese *manga* and *anime*; combination of the words *costume* and *play*

cossacks Peg-top trousers made with double straps under the instep worn by men during the early 19th century

costume Term used by scholars who study historic dress; also used in the theater or in dance or for masquerade

cote Costume historians use this French term instead of "under tunic" for under tunics worn by both men and women in the 13th century and after; placed over chemise or shirt; see also *surcote*

cote hardie Variant of the surcote or outer tunic used by men and women during the 14th century. For men in France, referred to a sleeved garment for outdoor wear; for men in England, referred to a garment for use over the pourpoint, with a distinguishing sleeve that ended at the elbow in front, while hanging down in back as a short tongue or longer flap; for women this garment may have been a fitted gown with a hanging sleeve.

cowboy shirt Shirt worn in the American west during the 19th century; featured a convertible collar, pockets in front, and a V-shaped yoke in front and back, often made of contrasting fabrics; sometimes worn with a neckerchief or a string tie, often closed with grippers; also called *western shirt*

cowl Originally a monk's hood that either was attached to the tunic or was a separate garment in the Early Middle Ages; later became part of lay costume

crackowe An elongated, exaggeratedly pointed-toed shoe used during the Middle Ages; also called *poulaine*

cravat Earliest usage applied to a large, scarf-like piece of fabric separate from the shirt that was worn around the neck instead of a collar by men in the late 17th century. In later periods, used as a general synonym for neckcloths or neckties of various shapes.

crinoline A device for holding out women's full skirts in the 1860s that could be made of crinoline fabric stiffened with horsehair or other materials such as frameworks of whalebone or steel. Also called hoop skirt or cage crinoline. Eventually used as a generic term to apply to any petticoat stiff enough to hold out a full skirt.

Crocs® The waterproof, no-slip shoe, perforated in the front and with a sling back; first appeared in the early 2000s

cross-gaitering See *leg bandages*

Crusades In the 11th century, under the urging of Pope Urban II, the European powers launched the first of many wars called Crusades intended to free the holy places of Christendom from the Muslims; one result was to bring cross-cultural influences to Europe.

cuirass Close-fitting, shaped armor used in ancient Greece that covered the body and protected the common soldier

cuirass bodice Extremely tight, boned women's daytime bodice of the mid-1870s extending down over the hips to mold the body

culots A type of trunk hose worn by men during the late 16th century; not much more than a pad around the hips with very tight-fitting hose

cultural authentication The process whereby elements of dress of one culture are incorporated into the dress of another

cummerbund A wide, pleated fabric waistband

curricle coat Large, loose men's overcoat (or greatcoat) with one or more capes at the shoulder, popular in the 1840s; also known as a *box coat*

cut-offs Jeans cut off at the knee and worn as shorts; popular with men and women; first appeared in the 1980s

cyclas Term used by some costume historians in referring to the surcote; sources vary in defining precisely how, when, and by whom the cyclas was worn

D

DA Men's longer hairstyle, with sideburns and a duck-tailed shape (initials "DA" are an abbreviation for duck's ass), cut at the back; popular in the 1950s

dagging Form of decoration used during the Late Middle Ages in which edges of the garment were cut into pointed or squared scallops

dalmatic An ancient Roman tunic used from the 2nd to the 5th centuries that was fuller than earlier tunics, featuring long, wide sleeves

dandy Term used for a man excessively fond of and overly concerned with clothes

dashiki A traditional African garment, collarless, wide shirt with kimono-type sleeves; first appeared as an item of fashionable dress in the United States during the Civil Rights movement of the 1960s

day cap Small muslin or lace caps of the early 19th century worn indoors

day dress Worn in the last half of the 19th century; suitable for walking and shopping; also called *promenade dress* or *walking dress*

deconstructionists Designers of the 1990s who took elements of garment construction and put them together in unusual ways, such as seams placed on the outside and fabric edges left unhemmed and raw

deerstalker cap Checked or tweed men's cap with visors on both the front and back and ear flaps that can be buttoned or tied to the top of the crown; popular in the 1870s

Delphos gown Pleated gown in which the front and back are laced together, rather than being stitched down the side, reminiscent of ancient Greek dresses; how the pleats were achieved is unknown; patented by designer Mariano Fortuny in 1909

demi-gigot sleeve Full from shoulder to elbow, then fitted from elbow to wrist, often with an extension over the wrist; popular in the early 19th century

denim Sturdy, serviceable fabric woven in the twill weave, traditionally made with indigo-blue or brown lengthwise yarns and white crosswise yarns; used in sportswear, work clothes, pants, and jackets and occasionally in high-fashion items

derby American term for a hat with a stiff, round, bowl-shaped crown and a narrow brim; see also *bowler*

designer jeans Almost twice as expensive as regular jeans, designer jeans prominently display the name of the designer on the posterior of the wearer; first appeared in the late 1970s

diadem A crown placed on the head that often held flowers, metals, or polished stones

diamonds by the yard From the 1970s, designer Elsa Peretti's string of gold chain with interspersed diamonds

dimity A cotton fabric with a woven, lengthwise cord or figure; first appeared in Europe by the end of the 13th century

diplax Small rectangle of fabric worn by women in ancient Greece, especially over the Ionic chiton, draped in much the same way as the himation

dirndl skirt A full women's skirt gathered into a waistline to produce a more bouffant effect, sometimes attached to a tight-fitted bodice; popular in the 1940s. It derives from a full-skirted Tyrolean peasant costume originating and still worn in the Austrian and Bavarian Alps.

dishrag shirt Net shirt that first became popular on the French Riviera in the 1930s

ditto suit Men's suit from the 18th century in which the same fabric is used for pants, jacket, vest, and sometimes cap

dolman During the 1880s, referred to a semi-fitted women's garment of hip to floor length that was shaped like a coat but had a wide-bottomed sleeve that was part of the body of the garment; was revived in the 1930s and 1940s as a popular women's sleeve construction

Doric chiton See *chiton*

Doric peplos An early form of the Greek version of a tunic that fitted close to the body and fastened at the shoulders with a large straight pin on each side holding the back and front of the garment together; worn from the Archaic Period until c. 550 BCE

double mantles Either open or closed mantles worn outdoors by women in the Early Middle Ages, usually lined in contrasting colors

doublet Originally a man's close-fitting, sleeveless garment with a padded front; worn during the Late Middle Ages, and varying in construction. Appears even more extensively as part of the Italian Renaissance and in the Baroque Period men's dress; see also *pourpoint* and *gipon*.

draped dress The arrangement of fabric that is loosely folded, pleated, pinned, and/or belted in different ways around the body

drawers A 16th-century English term for undergarment that evolved from braies or breeches

draw loom A special loom from China on which elaborately figured silk fabrics were produced; was in use in Italy by the Late Middle Ages, and by 1600 was being used wherever complicated patterns in silk fabrics were being woven

drawn bonnet A bonnet from the early 19th century made from concentric circles of metal, whalebone, or cane and covered in silk

dreadlocks Long hair arranged in many long hanging twists; first appeared in the United States in the 1970s

drip dry Easy-to-care-for fabrics that do not require ironing

drum farthingale See *French farthingale*

duckbills Wide men's shoes from the 16th century with decorations including slashing with puffs of fabric pulled through the openings; shape resembled the bill of a duck

duster Linen men's and women's motoring coats that first appeared in the early 20th century

E

Eisenhower jacket See *battle jacket*

empire waistline Ancient Greek–inspired style, revived during the Empire Period, in which the dress is belted high under the bustline

engageants French term for two or three tiers of lace, or sheer fabric ruffles, used as cuffs on sleeves; during the 18th century and in the Crinoline Period, referred to removable lace or muslin undersleeves (see Chapter Thirteen)

English drape suit Predominant cut for suits in the 1930s; this style fell softly with a slight drape or wrinkle through the chest and shoulders

English guard's coat From the 1930s, a dark blue men's coat with wide lapels, an inverted pleat in the back, and a half belt

ensembles Matching dresses and coats, or matching skirts, overblouses, and coats

eschelles Ribbons that covered stomachers from the 18th century

Eton crop A women's hairstyle in the 1920s that was exceptionally closely cropped and dressed like that of a man

Eton suit A boy's suit from the Romantic Period and after, which derived from the uniform of the Eton School in England; included a short, single-breasted jacket ending at the waist with a cut-square front, wide lapels, and a turned-down collar; also included a necktie, a vest or waistcoat, and trousers

Etruscans Pre-Roman people who migrated into Italy; by about 800 BC they had developed a culture that was superior in skills and artistic production, and more complex in organization, than the cultures of the neighboring tribes

eye of Horus In ancient Egypt, a stylized representation of the human eye that symbolized the moon

F

fade A men's hairstyle created by African American, inner-city youth in which the hair is cut very short on the sides and left long on top; it also began to have names, words, or designs shaved on the scalp; first appeared in the 1980s

fake fur High-pile synthetic fabrics that were first promoted in the 1970s as an environmentally sound alternative to real fur

falcon or vulture headdress Worn by Egyptian queens or goddesses; shaped like a bird of prey with the wings falling down at the side of the head and framing the face

fall The front opening of men's breeches or trousers from the 18th century where a square, central flap buttoned to the waistline

falling band A large, flat, turned-down collar attached to a men's shirt during the early 17th century; later made as a separate collar

false rump During the late 18th century, a pad tied at the back of the waist that supported the fullness of a woman's skirt; filled with cork or other light cushioning materials

farthingale See *French farthingale*

fashion A socio-cultural phenomenon in which a large number of people share a preference for a particular style; the preference lasts for a relatively short time, and then is replaced by another style

fashionistas Term coined in the early 2000s for affluent followers of certain fashion designers

fashion system A complex industry, well-developed by the early 20th century, that mass-produces clothing by linking together textile production, clothing design and manufacture, and retail distribution of clothing; has made fashionable clothing available in a wide variety of price ranges

feather cut Short, lightly curled woman's bob, cut in layers, popular in the 1950s and 1960s

fedora Low, soft man's hat with the crown creased front to back; first appeared in the 1920s and 1930s

fermail A round brooch from the Early Middle Ages used to close the top of the outer tunic, bliaut, or surcote; also called *afiche*

ferroniere Chain or band of metal or pearls worn across the forehead, with a jeweled decoration located over the center of the forehead; popular during the late 15th century for women

feudal society System developed out of the need for protection; to maintain his knights, a lord granted each of them land, called a fief or fiefdom, in exchange for military services; along with the fief came serfs, who worked the land for the lords and knights

fez Modern-day, traditional Arab head-covering shaped like a truncated cone; worn in southwest Asia or northern Africa; also called *tarbush*

fibula Pin used in ancient Rome for holding a garment together

fichu A sheer fabric or lace triangular kerchief worn with a very low neckline during the 18th and 19th centuries

fichu pelerine A variant of the pelerine used during the Romantic Period that had two wide panels or lappets extending down the front of the dress and passing under the belt

fillet A type of headband that first appeared in Mesopotamia and continued in use throughout the ancient world; revived in the 12th century as a standing linen band, rather like a crown, over which a veil might be draped; continued in use well into the 14th century

filling Yarns that run crosswise in woven fabric; also called *weft*

fish tails Additional stitched-on free-hanging panel or ruffle in front or back, simulating the tail of a fish

fitchets Slits in more voluminous outdoor garments of the Early Middle Ages; one could put the hands inside for warmth, or reach a purse hung from a belt around the waist of the garment beneath

flammeum Ancient Roman bridal veil of bright orange that covered the upper part of the bride's face

flannel A soft wool textile with fibers brushed up to create a napped surface

flapper Name applied to fashionable and modern young women of the 1920s who flouted the restraints applied to women in earlier periods

flat crown Appears on depictions of Queen Nefertiti, a New Kingdom queen of Egypt, who apparently wore this head covering over a shaved head

flats Shoes without heels

flat top General category of hairstyles in the 1950s, usually for men, in which the tip of the hair is cut to a flat surface

folk costume Dress of the European peasants; had its major development in the 18th and 19th centuries and was characterized by the use of traditional textiles and dress forms in order to associate oneself with a specific region or town. Stressed conformity and stability rather than change; folk dress in western Europe diverged from the mainstream of fashionable dress.

fontange An elaborate, tall structure for holding women's hair high on top of the head; made of three or four lace tiers in front, with a cascade of ruffles and bows in the back; popular in the late 18th century; called a *commode* in England and the Americas

foretop See *toupee*

foundation garment See *girdle*

four-in-hand Method of tying today's standard necktie

French bonnet Men's and women's hat style from the 16th century with a pillbox-like shape and a turned-up brim; some versions had decorative cutout sections in the brim

French farthingale Women's undergarment used for shaping floor-length dresses; steel or cane spokes of the same diameter were fastened from a topmost hoop at the waistband down; also known as a *wheel farthingale* or *drum farthingale*

frescos Mural paintings on plaster to decorate the walls and ceilings of buildings; first appeared in the ancient world, with the earliest known example dating back to 1500 BCE, and has been utilized throughout Europe and the Middle East ever since

fret Mesh snood or skullcap used during the Late Middle Ages, made of gold mesh or fabric worked in an openwork lattice design and sometimes decorated with jewels

frock A general term used in many periods for a woman's dress

frock coat Men's coat from the 18th century cut looser and shorter than a dress coat with a flat, turned-down collar; suitable for country wear and later accepted for formal wear as well

frock overcoat Cut along the same lines as the frock coat, but longer

full-bottomed wig Extremely large man's wig from the 18th century with a center part and small sausage curls

fulling Process whereby wool fabrics are washed and shrunk to produce a dense, close weave

G

gabled Type of coif; linen headcover shape for women during the Northern Renaissance; an English style shaped like a pointed arch

gaiters See *leg bandages* and *spats*

galligaskins Wide hose or breeches worn in the 16th and 17th centuries

galosh In the Baroque and Rococo Periods, a flat-soled overshoe with a toe cap for keeping it in place; rubber galoshes for wearing over shoes were introduced in the late 1840s

gambeson A knight's padded undercoat from the 14th century

gardecorps An outdoor men's garment from the Early Middle Ages with a full, unbelted outer tunic, a hood, and long, full, hanging sleeves, frequently worn with the arms passed through slits above the elbows; also spelled *gardcors*

garibaldi blouse Red, high-necked merino wool shirt worn by women, girls, and boys in the 1860s, with full sleeves gathered into wristbands and a small collar; named after the popular Italian general Giuseppe Garibaldi, who wore a similar red shirt as part of his uniform in the military campaign to unite Italy

garnache A long men's cloak with capelike sleeves from the Early Middle Ages; often lined or collared with fur, this garment was open at the sides under the arms

generation X Those born from the early 1960s to early 1980s, born after the *baby boomers*; sometimes perceived as lacking direction and as being disaffected; also called *Gen X*

geometric cut Haircut by Vidal Sassoon from the 1960s with bold lines and geometric shapes

Gibson girl and Gibson man Young women and men depicted by artist Charles Dana Gibson in the 1890s that were said to capture the ideal look for this period

gibus hat Collapsible men's top hat popular in the Romantic Period; used in the evening and constructed with a spring so that the hat could be folded flat and carried under the arm

gigot sleeve See *leg-of-mutton sleeve*

gilet corsage A women's front-buttoning jacket from the Romantic Period, made in imitation of a men's waistcoat

gipon See *pourpoint* and *doublet*

girdle In the Early Middle Ages, a jeweled belt (see Chapter Five); by the 20th century the term referred to an undergarment worn by women and girls designed to mold the lower torso, and sometimes the legs. It may include nonstretchable fabric panels and be made with or without garters, and is also called *foundation garment*.

globalization A process by which regional economies, societies, and cultures have become integrated through a globe-spanning network of communication and trade

go-go boots Calf-length white boots worn by girls in the 1960s

going frocks Shorter dresses worn in the 17th century by children old enough to walk

gores See *goring*

goring A process in which the shape of a skirt is created by using a number of panels (called *gores*) shaped so that when joined they fit the body in some areas, usually over the hips, and flare out in others, usually toward the bottom

gown Defined in slightly different ways in different periods, but generally meaning a skirted garment fully covering the upper and lower body and reaching to the ankle or the floor and worn by men or women. After the Renaissance tends to be a used for a woman's garment, especially for formal occasions, except when worn by men and women in professions such as law, religion, or higher education.

granny dresses Long daytime dresses derived from mod and hippie styles and worn in the 1970s

gray flannel suit A flannel suit for career-minded businessmen popularized in the 1950s

greatcoat A general term for overcoats; coats could be single- or double-breasted, were often as long as to the ankle, and their collars had a deep roll; coats were made with and without lapels

greaves In ancient Greece and ancient Rome, referred to leather or metal protectors for the lower legs; in later periods, referred to armor that protected the lower legs

guardaroba Italian Renaissance set of clothing made up of three garments: two layers of indoor clothing and a mantle for outdoors

guardinfante A Spanish variation of the French farthingale; wealthy Spanish women took up the style only around the mid-1600s, even though the farthingale was obsolete in the rest of Europe after the second decade of the 17th century. It was wider from side to side with a long, wide extension of the bodice below the waistline that extended over the top of the skirt; the bodice shoulder line was horizontal and sleeves were full and slashed, ending in fitted cuffs.

guild General term for a league or federation formed by craftsmen in order to regulate the number of artisans, set quality standards and rates of pay, and to regulate working conditions; first appeared in the 11th century

gusset Diamond or triangular-shaped piece of fabric inserted into a garment's structure to provide a wider opening to some area; makes greater comfort or fit possible

gynaeceum Workshop in ancient Rome in which women (mainly slaves) carried out weaving, dyeing, and finishing textiles

gypsy hat In the Directoire and Empire Periods, a woman's hat with a low crown and a moderately wide brim, worn with ribbon tied over the outside of the brim and under the chin

H

habit shirt A shirt worn by women during the Directoire Period as a fill-in under low necklines

hair *à la Titus* See *à la Titus*

hair *à la victime* See *à la victime*

handkerchief skirt Skirt from the 1920s with hemline cut to fall in points as if made of handkerchiefs

haubergeon A short coat of mail worn by a knight over the *gambeson* during the Late Middle Ages

hauberk Knee-length shirts of mail from the Early Middle Ages that were split in front for riding; also called *byrnie*

haute couture French businesses making custom-fitted clothing that was designed and made in the establishment of the designer; see *Charles Frederick Worth*

Hawaiian shirt Men's sport shirt printed with colorful Hawaiian floral or other local designs; made with a convertible collar and worn outside of trousers; first became popular in the late 1930s

headache band Headband from the 1920s; ones that were jeweled or had tall feathers attached were popular for evening

headband Strip of leather, cord, or fabric bound around the head horizontally across the forehead or over top of the head from ear to ear as an ornament or to keep hair in place; used since ancient times up to the present.

headrail Draped women's headcovering worn from the Middle Ages to the 16th century, made in different fabrics and colors; also called *coverchief*

hedgehog hairstyle A women's hairstyle from the late 18th century that resembled the fur of a hedgehog; the hair was curled full and wide around the face and long locks hung at the back

Helenistic chiton See *chiton*

hemhemet crown Headdress worn by Egyptian pharaohs, who used it only rarely, on ceremonial occasions, possibly because it was so awkward and unwieldy

henley shirt A ribbed-knit undershirt with a buttoned vent at the front of the neck; first appeared during the 1930s; also see *Wallace Beery shirt*

henna Orange-colored dye from the plant by the same name; ancient Egyptians used it to dye their fingernails

hennin A tall, exaggerated, steeple-shaped headdress style adopted by Burgundian women at the close of the 14th century

heraldic devices Special motifs and symbols associated with the nobility and their families; used in the Middle Ages

Hercules knot Belt tied with a double knot worn by a bride in ancient Greece; its loosening took place on her wedding night

herigaut A full men's garment from the 13th century with long, wide sleeves and a slit below the shoulder in front through which the arm could be slipped, leaving the long, full sleeve hanging behind; also worn by women

heroin chic Term applied to fashion advertising and magazine photography style of the late 1980s and 1990s in which models appear emaciated, pale, and unkempt, with large circles under their eyes, an appearance likened to that of drug addicts

hidden rivet jeans Blue jeans with rivets hidden inside the pockets; made by Levi Strauss between 1937 and about 1960

high stomacher dress A dress from the early 19th century with a complex construction in which the bodice was sewn to the skirt at the back only, with side front seams left open to several inches below the waists, and a band or string was located at the front of the waist of the skirt. The bodice often had a pair of under flaps that pinned across the chest, supporting the bust; the outer bodice closed in front by being wrapped across the bosom like a shawl, laced up the front over a short undershirt, or buttoned down the front.

high-tech fabrics Fabrics first produced in the 1980s and 1990s from manufactured fibers with special performance characteristics (e.g., water repellence, strength, stretch, heat resistance)

high-tech footwear Expensive sneakers for walking that became a status symbol in the 1980s

hijab A headscarf worn by many Muslim women who follow Islamic teachings; today it is used in combination with acceptably modest contemporary styles

himation A large rectangle of fabric that wrapped around the body, used by men in ancient Greece and similar to the wrapped shawls of Mesopotamia; usually draped over the left shoulder and under the right arm

hip huggers Low-slung pants of any style starting below the normal waistline, usually with the belt resting on the hips; first popular in the mid-1960s

hobble skirt Women's skirt from about 1912 that was rounded over the hips and tapered to the ankle so narrowly that walking was impeded

holoku A loose-fitting, full-length dress with a high neck and long sleeves that fell from a yoke; became traditional part of Hawaiian dress after missionaries in the early 19th century adapted their own dress style for the overweight Queen Dowager Kalakua

homburg Man's hat of rather stiff felt with a narrow rolled brim and a lengthwise crease in the crown; popular in the late 19th century and subsequently from time to time

hoodies Fitted, waist-length cardigan sweaters with attached hoods; first appeared in the late 20th century

hookless fasteners Zipper device from the early 20th century used in corsets, gloves, sleeping bags, money belts, and tobacco pouches

hoops Structure of metal, cane, wire, or wooden hoops for holding out women's skirts; the shape of the hoop varied depending on the silhouette that was popular at the time the hoops were worn; see also *panniers*

hose Stockings that had different lengths and uses in different time periods

hot pants Slang term describing women's short shorts from the early 1970s; made of luxury fabrics and leather, worn with colored tights and fancy tops both as evening wear and on city streets

houce A wide-skirted overcoat with winged cape sleeves and two flat, tongue-shaped lapels at the neck; used during the Late Middle Ages; French variation of the *garnache*; also spelled *housse*

houppelande Originating as a man's house coat worn over the pourpoint during the Late Middle Ages, became a garment for general wear; later also used by women; was fitted over the shoulder, then widened below into deep, tubular folds or pleats, which were held in place by a belt

houppelande à mi-jambe A mid-calf version of the houppelande for men that appeared in the 1400s

houseboy pants Pants worn by women in the 1950s that ended at the calf

housse See *houce*

huke Garment worn by upper-class men during the Late Middle Ages that was shaped much like a tabard, being closed over the shoulders and open at the sides; short versions had a slit at the front for ease when riding; longer versions for walking had no slit

Hussar front or beak A point at the front of a lengthened waistcoat; popular in the 1840s

I

idiot or imbecile sleeve Extremely full from shoulder to wrist, where it gathered into a fitted cuff; popular in the 1820s and 1830s; name derived from the fact that its construction was similar to that of sleeves used on garments for confining mad persons—a sort of "strait jacket" of the period

Incroyables The men who affected the most extreme of the Directoire styles, and wore waistcoats that fit loose at the shoulders, excessively tight breeches, and cravats or neckties and collars that covered much of their chins

Indian gown See *banyan*

indispensables See *reticules*

indutus See *amictus*

innocente See *sacque*

instita Term used by Roman writers to describe the distinctive dress of a Roman matron; scholars have disagreed about its construction—some interpret it as a ruffle at the bottom of the tunic that covered the feet, others see it as a dress suspended from sewed-on straps. Also known to costume historians as a *stola*.

Inverness cape A large, loose men's overcoat with full sleeves and a cape ending at wrist length, popular during the Crinoline Period

Ionic chiton See *chiton*

J

jabot Frilly ruffles of cambric or lace placed at the front of the neck of women's bodices; popular during the Edwardian Period

jack boots High, rigid men's boots made of heavy leather; popular during the late 17th century

jacket Term originally used interchangeably with *cotehardie* during the Late Middle Ages; similar in function (though not in cut) to the modern suit jacket, although it was worn with hose rather than with trousers

Jeanette A cross or heart of pearls suspended by a narrow tress of women's hair or a piece of velvet ribbon around the neck; popular during the 1830s

jeans See *Levi's*

jerkin In England after 1500, term used synonymously with *jacket*

jersey fabric A wool knit fabric used for clothing for active sports

Jockey shorts® Trademark for knitted briefs

jodhpurs Tight-fitting trousers that reach to the ankle, where they end in a snug cuff; originally imported from the city of Jodhpur, India during the British occupation in the latter half of the 19th century; became popular for military uniforms; after 1940, predominantly used for horseback riding

Juliet cap Small skullcap made of rich fabric (or sometimes entirely of pearls, jewels, or metal chain) worn during the Edwardian Period for evening or with wedding veils

jumps The term applied to loose, unboned bodices worn by women at home during the 18th century to provide relief from tight corseting

justacorps See *surtouts*

K

kaffiyeh A black-and-white headscarf associated with the late Yassir Arafat and his Palestinian countrymen; some American men and women adopted this in urban areas during the early 2000s, unaware of its political implications

kalasiris or calasiris Ancient Egyptian fringed tunic, sometimes inaccurately described as a long, tight-fitting, sheath-type dress

Kate Greenaway styles Children's dress based on illustrations by Kate Greenaway, an Aesthetic Movement illustrator of children's books; typical costumes were made of lightweight fabric printed with flowers and styled with a high waistline, puffed sleeves, and ankle-length skirts trimmed with narrow ruffles, worn with ribbon sashes, visible pantalettes, and mob caps or poke bonnets

kaunakes Skirts worn by both men and women from 3500 to 2500 BC; made of fleece or fleece-like materials

kente cloth Complex, elaborate, multicolored, woven designs made on narrow strip-looms by Ashanti men in Bonwire, Ghana; the cloth is expensive and highly prized; first became popular with African Americans during the Civil Rights movement of the 1960s

kiddie couture The production of expensive clothing for children by well-known designers; first appeared during the late 20th century

kilt Short skirt worn by Scotsmen; term often used as a means of distinguishing between male and female skirts

knickerbockers Men's sportswear garment that first appeared after 1850; full and loose, gathered into a band that buckled just below the knee; also worn by preadolescent boys; popular until the 1940s and occasionally worn today, mostly for athletics or sportswear; the term shortened to *knickers*

knickers See *knickerbockers*

knock-off An item of apparel copied from a more expensive item and generally manufactured from lower-priced components so it can sell at a lower price

kohl A black cosmetic paint used by ancient Egyptian women to accent their eyes; made of galena, a sulfide of lead

L

L-85 regulations Guidelines in the United States during World War II that restricted the quantity of cloth that could be used in clothing; savings in fabric were made by eliminating trouser cuffs, extra pockets, and vests with double-breasted suits, and by regulating the width of skirt hems and the length of men's trousers and suit jackets

lace Differs from either cutwork or fillet in that it is constructed entirely from threads, dispensing with any backing fabric; two types include *bobbin* or *pillow lace* and *needlepoint lace*

lacerna A rectangular cloak from 3rd century CE Rome with rounded corners and a hood

lacing A means of closing garments by threading cords called laces back and forth through openings in fabrics in a way similar to lacing shoes

lacis Decorative technique in which the artisan embroiders patterns on a net background

Lacoste® shirt Introduced in the 1920s, an internationally recognized trademark used extensively on apparel as well as other goods; originally identified the knit shirts manufactured by La Chemise Lacoste of Paris, marked with a small alligator symbol on the left front

laena A cloak from 3rd century CE Rome that was made of a circular cloth folded to a semicircle, thrown over the shoulders, and pinned at the front

lappet Long, decorative lace or fabric streamer on a garment or headdress

Lastex® In fashion, refers to a fabric made from yarns with a rubber core covered by another fiber; results in a form-fitting and wrinkle-free fabric; often used in bathing suits in the 1930s

latchets Shoe laces used in the 18th century that crossed the tongue from either side

leading strings Small strings used during the 17th century to help hold a child upright as he or she learned to walk and retained for another two years or so to help control the child's movements

leg bandages Strips of linen or wool wrapped closely around men's legs to the knee and worn either over the hose or alone; considered a forerunner of stockings

leglet A sort of half *pantalette* that tied around the leg; worn under dresses in the Romantic Period

leg makeup Makeup with which women painted their legs to simulate the color of stockings, including a dark line down the back of the legs in imitation of the seams, to make up for shortages of fabrics for stockings during World War II

leg-of-mutton sleeve Sleeve full at the shoulder, gradually decreasing in size to the wrist where it ended in a fitted cuff; popular in the 1830s and in the 1890s; also called *gigot sleeve*

leg warmers Knitted covering for the legs extending from the ankle to the knee or above; first appeared in the 1980s

leisure suit Men's suit styled in knit or woven fabric in a casual style with the jacket similar to a shirt, having a convertible collar, more sporty buttons, and sleeves with single or no cuffs; popular in the 1970s

leotard A two-piece, knitted, body-hugging garment; originally worn by dancers and acrobats in the 19th century, it became part of fashionable dress in the 1960s

le pouf A wide, puffy skirt with a light airy appearance, made in both short and longer styles around 1985; created by Christian Lacroix, designing for Patou

lettice Trimmings and linings used during the Late Middle Ages made of ermine and a fur resembling ermine; reserved for women of the nobility

Levi's Sturdy, close-fitting workpants that were manufactured by Levi Strauss during the Gold Rush and sold to miners; originally made of heavy-duty canvas, and later from denim dyed blue with indigo; became a classic fashionable garment for men and women; also called *jeans* or *blue jeans*

Liberty® print Trademark of Liberty, London; applied to various prints that were often small, multicolored floral designs

licensing The sale of the right to use an image or design by the owner (licensor) to a manufacturer (licensee), in return for payment of royalties to the licensor who continues to own the rights to the original image or design

line-for-line copies American interpretations of Parisian and Italian couture dresses made expressly for American stores; a popular practice in the 1950s

linen Fiber that is removed from the stems of the flax plant

lingerie dress White, frilly cotton or linen dress with decorations including tucking, pleating, lace insertions, bands of applied fabric, lace, and embroidery; worn during the Edwardian Period

liripipe The long hanging tail of the *chaperon*; also called *cornette*

Little Lord Fauntleroy suit A child's suit that consisted of a velvet tunic ending slightly below the waist, tight velvet knickerbockers, a wide sash, and a wide, white lace collar

livery Costume of nobles and servants of the Late Middle Ages, as well as officials of the court and ladies-in-waiting to queens or duchesses; distributed by kings, dukes, and feudal lords; eventually came to mean special uniforms for servants

lock of Horus Distinctive hairstyle worn by children of Egyptian pharaohs; one lock of hair remained on the left side of the head; also called *lock of youth*

lock of youth See *lock of Horus*

loincloth Length of cloth wrapped to cover the genitals

longuette Radically longer lengths on coats, skirts, and dresses, reaching from below the knee to ankle length; this was an abrupt change from the miniskirts of the late 1960s

lorum Long, narrow, heavily jeweled scarf that became part of the official insignia of the Byzantine emperor; possibly evolved from the Roman toga with the folded bands

lounge coat During the Edwardian Period, a loose, comfortable man's jacket that had no waistline, a straight front, a center vent in the back, sleeves without cuffs, and a small collar with short lapels

love lock Long lock of curled hair that was brought forward from the nape of the neck and hung over the chest; worn by men during the mid-17th century

lumber jacket Waist-length jacket with a bloused effect and rib-knitted bands at waist and cuffs; made of woven plaid wool fabric; originally worn by woodsmen in the lumbering trade and introduced for sportswear in the later 1920s, worn by both adults and children

M

macaroni Name for young men in 18th-century England who were noted for wearing brightly colored silks, lace-trimmed coats in the latest silhouette, and fashionable wigs and hats; derived from the Macaroni Club, which was formed those by who affected an interest in continental culture

mackinaw A hip-length sport jacket made of heavy wool woven in patterns similar to those used for blankets; popular for boys in the Edwardian Period

mackintosh A waterproof coat made of rubber and cut like a short, loose overcoat; developed in the Romantic Period and continued in use; became a British synonym for a rain coat

magyar sleeve A sleeve cut very full under the arm, tapering to a close fit at the wrist; first appeared in the Early Middle Ages

mail Armor made of interlocking metal rings; first used in the Early Middle Ages

mancheron Very short oversleeve, similar to a large epaulette, worn by women during the Romantic Period

manga Japanese word for "cartoon"; led young Japanese to engage in *cosplay*, or dressing up as the characters from manga; the practice spread beyond Japan, and over time, the word *cosplay* came to mean dressing as any character

manteau See *mantua*

mantilla A large, oblong, fine lace veil first used by Spanish women in the 17th century to cover the hair; a smaller version of the mantle was worn by women during the medieval period

mantle A loose, sleeveless cloak or cape that appeared throughout history; variations include *closed, open, double,* and *winter mantles*

mantlet A hybrid between a shawl and a short cape with points hanging down at either side of the front, used by women during the Romantic Period; also known as a *shawl mantlet*

mantua Women's gown of the late 17th and early 18th centuries that was cut in one length from shoulder to hem and worn over a corset and an underskirt; also called *manteau*

mappa A white linen table napkin used in ancient Rome; guests brought their own napkins when invited to dinner

marcel wave Artificial wave put in woman's hair with heated curling irons, devised by hairdresser Marcel of France in 1907 and popularized in the 1920s

Marco Polo 11th-century Italian merchant, one of the first Europeans to visit large parts of the Far East, who wrote an influential book about his travels

Marie sleeve Full to the wrist, but tied in at intervals with ribbons or bands; popular for women during the Romantic Period

mass customization The use of flexible computer-aided manufacturing systems to produce custom output combining the low unit costs of mass production with the flexibility of individual customization

mauve The name given to the color produced by the first coal tar dyestuff, synthesized in 1856

maxi Term used for ankle-length daytime skirts, popular with women in the late 1960s as a reaction against miniskirts

Medici collar Open ruffs, almost a cross between a collar and a ruff, stood high behind the head and fastened in front into a wide, square neckline; named for the 16th-century Medici queens of France, Catherine and Marie, during whose reigns this style was popular; style revived in the 18th and 19th centuries

mercerizing The process of treating cotton fabric with sodium hydroxide, which improves strength, receptivity to dyes, and luster

Merveilleuses Women who affected the most extreme of the Directoire Period styles, with long flowing trains, the sheerest of fabrics, necklines cut in some extreme cases to the waistline, and huge, exaggerated jockey-like caps

microfibers Manufactured filament fibers that measure 10 denier per filament or less

micro mini The shortest of the short skirts; first appeared in the 1960s

midi skirt A mid-calf-length skirt; first appeared in the 1960s

minaret tunic A wide tunic, boned to hold out the skirt in a full circle and worn over the narrowest of hobble skirts; designed by Paul Poiret for women during the Edwardian Period

mini-crinolines Wide-skirted, short dress popular in the 1980s

minimalists Influential designers of the late 1990s who made styles in neutral or darker tones that used little ornamentation and had good lines

miniskirt Term first used in the 1960s to describe a short skirt from 4 to 12 inches above the knee; see also *micro mini*

mi-parti Men's and women's garments of the Late Middle Ages, decorated by sewing together sections of different-colored fabrics; also called *parti-colored*

mitts Gloves, cut to cover the palm and back of the hand but not the fingers; first appeared in the Romantic Period; also known as *mittens*

mixtures Styles that incorporate components from several cultures

mob cap A women's indoor hat from the early 18th century, with high, puffed-out crowns at the back of the cap and wide, flat borders that encircled the face

moccasins Footwear of the American native people made with a firm sole and soft leather uppers; originally made from deer or moose skin; adopted and adapted by settlers, it has became a classic shoe style with many variations in its design

modeste The French term for the outer skirt of a women's dress, used in the mid-17th century

mods Groups of young people in Britain in the mid-1960s; espoused the notion that men and women were entitled to wear handsome and dashing clothing, as well as "long hair, granny glasses, and Edwardian finery"; style gained international attention after being adopted by The Beatles

monastic A bias-cut, full tent dress by designer Claire McCardell that, when belted, followed the body contours gracefully; popular in the 1940s and 1950s

monk's front boot Closed shoe with wide buckled strap over the tongue at the instep rather than lacings; popular for women in the 1940s and for men during World War II, when this style was favored by U.S. Army Air Corps officers

mordant Substance used to fix dyed colors in fabrics so they do not fade

morning coat Men's coat of the 1860s, also called *riding coat* or *Newmarket coat*, that curved back gradually from the waist

mourning crape A black, silk fabric with a crinkled or uneven surface texture; worn by widows for a year and a day as part of the "first mourning" costume of the late 19th century. The modern spelling "crepe" means woven fabrics made from tightly twisted yarns and is not the same fabric as mourning crape.

muckinder A handkerchief from the 17th century pinned to the front of a baby or toddler's dress; used like a bib or apron is today

mules Backless slippers, especially popular for women in the 18th century

multichannel retailing The integration and use of a variety of channels in a customer's shopping experience, including physical stores, websites, and catalogues

muslin Very fine cotton fabric from Bengal that became enormously popular in the late 18th and early 19th centuries, despite exorbitant prices, due to its softness and drapability; in later periods, less delicate, plain-weave cotton or cotton-blend fabrics have also been called "muslin"

muslin fever Name applied to pneumonia and other respiratory infections that were blamed on the fashion for wearing lightweight muslin dresses in the Empire Period

mu'umu'u Loose-fitting, full dress worn by native Hawaiian women that was adapted from European chemises; worn for swimming and sleeping until the 1930s, when it was adopted for street wear

N

nappies See *tailclouts*

needlepoint lace Originated in Italy; made by embroidering over base threads arranged in a pattern, and connecting these base threads with a series of small intricate stitches

negro cloth A coarse, white homespun used in the 18th century for clothing for enslaved people in the West Indies and American South

Nehru jacket Single-breasted jacket, slightly fitted, with a standing collar; introduced in the late 1960s, it takes its name from Prime Minister Jawaharlal Nehru of India

nemes headdress Worn by Egyptian rulers from the Old to the New Kingdom; a scarf-like construction that completely covered the head and was fitted across the temple, hanging down to the shoulder behind the ears, and with a long tail at center back that symbolized a lion's tail

nether stocks From the 16th century, lower section of a type of men's hose that was sewn together with the upper stocks

New Look Post–World War II Parisian fashion that took dramatic new directions, introduced in Christian Dior's spring 1947 show, which deviated sharply from the styles of the wartime period; characterized by sharply dropped skirt lengths, enormously full skirts or pencil-slim skirts, a round shoulder-line, and a small, nipped-in waistline. Many clothes were made from new and popular "easy-care" synthetic textile fabrics such as nylon, polyester, and acrylics; dominated fashion design until the mid-1950s.

Newmarket coat A men's coat from the Romantic Period that sloped gradually to the back from well above the waist

Norfolk jacket A belted, hip-length men's jacket from the Bustle Period with two box pleats from shoulders to

hem, front and back; later on in the same period, also worn by women

nylon Generic fiber category established by the FTC for a manufactured fiber composed of a long chain of chemicals called polyamides

nylons Long, sheer stockings made of nylon

nymphides Special sandals worn by brides in ancient Greece

O

op art Shortened form for name given to "optical art" of the 1960s that created visual illusions through largely geometric patterns

open breeches During the late 16th century, wide, full breeches worn by men to cover the lower part of the body

open mantles Garments made from one piece of fabric that fastened on one shoulder, first used in the 10th century

orarium White linen handkerchief used in ancient Rome that was slightly larger than the sudarium; became a symbol of rank, and in the late Empire, was worn by upper-class women neatly pleated across the left shoulder or forearm

original Garment designed and made in the couture house, but which is not necessarily the only one of its kind

orphrey Y-shaped band of embroidery that extended from each shoulder to form a vertical line in the back and front of the chasuble; used by the clergy in the Early Middle Ages

Oxford bags Men's long trousers with very wide cuffed legs; popular in the 1920s, based on the style that began at Oxford University in England

P

paenula A heavy wool cloak from ancient Rome, semicircular in shape, closed at the front, with a hood

pageboy Straight hair worn shoulder-length or shorter, with ends curled under very smoothly at the back and sides; popular in the late 1930s

pagoda sleeves Sleeves from the Crinoline Period that were narrow at the shoulder and expanded abruptly to a wide mouth at the end; sometimes shorter in front, longer in back

pair of bodys Corset from the 16th century cut into two sections and fastened at the front and back with laces or tapes

paisley shawl A 19th-century shawl manufactured in the Scottish town of Paisley; made in imitation of the popular cashmere (or Kashmir) shawls from India using less-costly wools and silk; imprinted with a stylized version of the Indian motif called a *boteh*. Because of the motif's association with the shawls from Paisley, the design is now known as "paisley"; see also *cashmere shawl*.

pajamas One- or two-piece item worn by men and women, originally designed in the Edwardian Period for sleeping; in the 1930s, was also used by women for lounging at home or on the beach, and was a way for them to wear trousers, which previously had been worn exclusively by men

palazzo pajamas Women's long, wide pajamas or culottes with voluminous flared legs and gathered waist; worn for lounging or evening dress in the late 1960s and early 1970s

paletot A woman's outdoor garment from the Romantic Period, about knee-length and having three capes and slits for the arms; also the name for a man's knee-length overcoat

palla A women's shawl used in ancient Rome; draped over the outer tunic similarly to the toga, casually across the shoulder, or over the head like a veil

pallium Evolved form of the ancient Greek himation; in ancient Rome, was a broad rectangle draped around the shoulders, crossed in front, and held in place with a belt; in the Byzantine Empire, was also called a *lorum*, and consisted of a long, narrow, heavily jeweled scarf that became part of the official insignia of the emperor

paltock From the early 16th century, English term for a man's doublet to which hose were anchored

paludamentum A large white or purple cloak similar to the Greek chlamys, worn by emperors or generals in ancient Rome (see Chapter Four); cloak worn by men and women of the Byzantine Empire that fastened over the right shoulder with a jeweled brooch

panama hat Hand-woven hat made in Ecuador of fine, expensive straw obtained from the leaves of the jipijapa plant; popular for men in the Edwardian Period; named for the port of sale to which they were shipped before being sold in the United States, Europe, and Asia

panes Narrow strips of fabric placed over contrasting linings to ornament garments; especially popular during the Renaissance

panniers Structure of metal, cane, wire, or wood hoops used in the 18th century for extending a woman's dress at both sides at hip level

pantalettes Long, straight, white drawers trimmed with rows of lace or tucks at the hem that became fashionable for a short time around 1809; young girls, however, wore pantalettes under dresses from the Romantic Period through to the end of the Crinoline Period

pantaloons Garment cut from waist to ankle in one piece; at various times it was cut to fit either close to the leg or fuller; by the 19th century the terms *pantaloons* and *trousers* were sometimes used interchangeably

panties Term first used in the 1920s for garments worn by women and children under clothing, covering the torso below the waist

pantofles Heel-less slippers or mules for women, popular in the late 17th century

panty brief Short underpants worn by women and girls in the 1930s, sometimes made of control stretch fabric with garters added; later known as *briefs*, since they grew shorter in order to fit under active sportswear

pantyhose Hosiery first marketed around 1960 as an alternative to nylon stockings; made with textured, sheer nylon yarn that follows the design of tights, having stockings and panties cut in one piece

paper dresses Classification of dresses made from various types of disposable paper or nonwoven fabrics; a fad from 1968

pardessus A term applied in the Romantic Period to any of a number of garments for outdoor wear that had a defined waistline and sleeves and were from one half to three quarters in length

parka Loose-fitting, pull-on jacket made with an attached hood that is sometimes trimmed with real or synthetic fur; worn originally by the Eskimos and introduced during the 1930s for winter sportswear; later versions also opened down the front

parti-colored See *mi-parti*

pashmina A synonym for *cashmere* used in the 1990s and after to promote fine-quality cashmere apparel

patches Small fabric shapes glued to the face during the 17th century to cover imperfections or skin blemishes

pattens Overshoes from the 18th century that protected against wet and muddy surfaces; similar to *clogs*, they were made of matching or other fabrics and had sturdy leather soles, built-up arches, and latchets that tied across the instep to hold the shoe in place. Less fashionable versions for working people were made with metal soles and leather fasteners; see also *chopines*.

Paul Poiret Leading innovative Parisian couturier from 1903 to World War I who seemed to have captured the spirit of the age

Peacock Revolution Radical changes in men's wear during the 1960s from the conventional clothing to a more relaxed, more creative, colorful, and unconventional style, included turtleneck knit shirts, Nehru jackets, flared pants, Edwardian coats, and other items

pea jacket Loose, double-breasted jacket with side vents and small collar; worn as an overcoat during the Crinoline Period; also called *reefer*

peascod belly Pronounced front of the doublet popular by 1570 that resembled the puffed-out chest of a peacock

pecadil A row of small, square flaps placed just below the waist of the doublet, popular in the second half of the 16th century

pectorals Decorative necklaces for men and women used in the ancient world, often featuring semiprecious and precious stones such as carnelian, lapis lazuli, feldspar, and turquoise, as well as religious symbols

pedal pushers Below-the-knee, straight-cut women's pants, often cuffed; popular during World War II for bicycling

peg-top skirt A skirt from the Edwardian Period cut full at the waistline with darts, gathers, or small unpressed pleats, and tapered inwards from the hip, becoming very narrow at the hem

pelerine Wide, cape-like collar that extended over the shoulders and down across the bosom; popular for women in the Romantic Period

pelerine-mantle A mantle with a deep cape, coming well over the elbows and having long, broad front lappets worn over, not under, a belt; popular for women in the Romantic Period

pelisse A 19th-century garment similar to a modern coat; generally full-length, it followed the typical Empire silhouette

pelisse-mantle A double-breasted, sleeved, unfitted coat with wide, flat collar and wide, reversed cuffs; worn during the Crinoline Period

pelisse-robe Daytime dress, adapted from the pelisse coat, that was fastened down the front with ribbon bows or with hidden hooks and eyes; used from about 1817 to 1840

Perfecto motorcycle jacket Black leather jacket that became the symbol for rebellious youth of the 1950s

perizoma A fitted loincloth garment worn by ancient Greeks and Etruscans that covered much the same area as modern athletic briefs

permanent press Easy-to-care-for fabrics that appeared in the 1960s; chiefly cotton and cotton-blended with polyester and some wool fabrics; given special treatments to render them more readily washable and requiring little or no ironing

petasos Wide-brimmed felt hat worn in ancient Greece to provide shade in summer or keep rain off the head

pet-en-lair A short, hip-length bodice from the 18th century worn with a separate, gathered skirt

petticoat In the 16th century, an underskirt worn with an overdress that created an overall silhouette rather like an hourglass; in later periods, an underskirt that was sometimes an invisible undergarment and sometimes a visible garment

petticoat breeches A divided skirt that was cut so full that it gave the appearance of a short skirt, worn by men in the 17th century; also called *rhinegraves*

Phrygian bonnet Brimless cap with a high, padded peak that fell forward; worn in ancient Greece

picture hat Hat with a large brim framing the face, frequently made of straw; popular for women in the Edwardian Period

pillow lace See *bobbin lace*

pilos Narrow-brimmed or brimless hat with a pointed crown, worn in ancient Greece by both men and women

pinafore During the 17th century, apron-like pinafores replaced bibs; the term derived from the practice of pinning this garment to the front or forepart of a child's gown; also worn over the dresses of young girls from the late 19th century into the 20th century

pinner From the 18th century, circular cotton or linen cloth cap with single or double frills around the edge, placed flat on the head

placard See *plastron*

plastron French word for a stiffened panel with a rounded lower edge; part of the surcote, it joined a wide band encircling the hips to which the skirt was attached; worn during the Late Middle Ages; in English, called a *placard*

plumpers Small balls of wax, placed in the cheeks to give the face a fashionably rounded shape; popular practice in the late 17th century

plus fours A fuller version of knickers from the 1920s

points In the Late Middle Ages, laces or ties that ended in small metal tips, or "points," and were used to close or join various parts of a garment

polo coat Coat made of tan camel's hair worn by a British polo team playing exhibition matches in the United States; its popularity continued into the 1930s

polonaise Fashionable from about 1770 to 1785, an overdress and petticoat in which the overskirt was puffed and looped by means of tapes and rings sewn into the skirt, with a hoop or bustle supporting the skirt. In subsequent periods, the term was used very broadly to refer to any overskirt puffed or draped over an under layer

polo shirt Knitted shirts with attached collars and short, buttoned neck vents; style originated as costume for polo players, but was adopted generally for informal wear in the 1920s and after

pomander Perfume holder mounted on the long cord of a woman's jeweled belt; used during the 16th century

pomander balls Small balls of perfume used during the 17th century; enclosed in a decorated, perforated box, or pomander, that might be shaped like an apple

pompadour A hairstyle from the mid-18th century in which the hair is built high in front and at the sides around the face; named after Madame de Pompadour, mistress of King Louis XV

poodle skirt Full-circle skirt very popular with adolescents of the late 1940s and early 1950s; was often made of felt and decorated with an appliquéd poodle dog; revived as a style for young girls in the late 20th century

poorboy sweater Tightly fitting, rib-knit sweaters from the 1960s and 1970s that looked as if they had shrunk

pop art Short for *popular art*, entered the art world during the 1960s, featured glorified representations of ordinary objects such as soda cans and cartoon figures

postmodernism A genre of art and literature and especially architecture in reaction against the principles and practices of established modernism

poulaine See *crackowe*

pourpoint Close-fitting, sleeveless garment with a padded front that originated as military dress; worn by men from the 14th to 17th centuries; also called a *doublet* or *gipon*

power suit Term used in the late 1980s and 1990s for a man's or woman's tailored suit worn for business

preppy Style from the 1980s that stressed classic tweed blazers, conservatively cut skirts or trousers, tailored blouses or shirts, and high-quality leather loafers, oxfords, or pumps; style referred to affluent students who attended private preparatory schools, continued on to Ivy League colleges, and later became *yuppies*

pre-Raphaelite movement A group of Victorian Period painters who took their themes from medieval and Renaissance stories; as they made costumes for their models to wear, the women of the group also adopted these dresses for everyday use

prêt-à-porter French term for *ready-to-wear*; in the mid-1960s, after becoming established in the haute couture, young designers (like Yves Saint Laurent, Pierre Cardin, André Courrèges, and Emanuel Ungaro) who had trained under men like Dior and Balenciaga opened their own establishments and expanded in the direction of ready-to-wear clothes

princess dress A one-piece style from the Crinoline Period that, instead of having waistline seams, was cut with long, gored sections extending from the shoulder to the floor

princess petticoat A camisole-type top combined with a petticoat to create a single princess-line garment; see *princess dress*

princess polonaise Princess-style dress with the outer fabric looped up or draped over the hip

promenade dress See *day dress*

pschent crown Worn by Egyptian pharaohs to symbolize rule over Lower and Upper Egypt; consisted of a combination of the red and white crowns of Lower and Upper Egypt

pudding A special padded cap worn in the 17th century by toddlers learning to walk

puffs Decorative device used on clothing of the Middle Ages in which small amounts of fabric in contrasting colors were pulled through slashes made in the outermost fabric layer

pullover Knitted sweater that pulled over the head; became popular for men and women after 1915

punk style An exaggerated theatrical look originating in the 1970s; included ripped shirts, leather clothing, and extreme hairstyles

"putting out" system System popularized for the textile industry of the Late Middle Ages in which a merchant became the middleman for textile workers, selling the workers the fiber, then buying back the finished cloth, followed by selling it to the fuller, then buying it back; the merchant arranged for dyeing, then sold the completed fabric to agents, who sold it at medieval trade fairs

Q

queue A lock or pigtail at the back of the head; especially popular in the mid-18th century as part of men's wigs

quick response Computer-based systems created in the 1990s that permit rapid ordering, manufacture, and delivery of goods

quizzing glasses Magnifying glasses mounted on a handle and worn around the neck; popular in the early 19th century

R

raglan cape A full overcoat with an innovative sleeve construction popular during the Crinoline Period; the sleeve was joined in a diagonal armhole seam running from under the arm to the neckline

raglan sleeves Sleeve style with seams running from below the arm at front and back to the neck rather than being set into the armhole

rationals Popular name for full pleated serge bloomers or knickerbockers worn by women for bicycling in the 1890s

rayon Generic fiber name for manufactured cellulosic fibers regenerated from short cotton fibers or wood chips

red crown Worn by Egyptian pharaohs to symbolize rule over Lower Egypt

redingote 18th-century full overcoat originating in England that had a large collar and was worn for riding

redingote dress 18th-century gown that resembled buttoned redingcote greatcoats with wide lapels or revers at the neck

reefer See *pea jacket*

reticules Small handbags, often with a drawstring at the top, popular in the Empire Period; also called *indispensables*

retro Term coined in the late 20th century for fashions from past eras that are updated as current styles

revers Lapels used during the Late Middle Ages that turned back to show the underside on the V of a gown's bodice; also a contemporary fashion term for this type of lapel

rhinegraves See *petticoat breeches*

ribbons of childhood Broad ribbon or tube of fabric—as compared with the narrow, ropelike *leading strings*— attached to the shoulders of children's dresses in the 17th century

riding coat See *morning coat*

rincinium A garment worn by widows in ancient Rome instead of a palla for a year of mourning; it was probably dark-colored, but its precise form is unclear

robe à la Française An 18th-century dress with a full, pleated cut at the back and a fitted front

robe à l'Anglaise An 18th-century dress with a close fit in the front and at the back

robe battante See *sacque*

robe de style Evening dress of the 1920s with a dropped waistline and full skirt

robe volante See *sacque*

roc Loose-fitting gown worn during the Late Middle Ages that appears infrequently, seemingly most often in Flemish and German paintings; the bodice was cut with a round neckline with a cascade of gathers or pleats at the very center of the front and back

rockers Style associated with tough young British men in the late 1950s; costume was a mixture of storm trooper and motorcyclist

Rococo style Supplanted the Baroque style from 1720 to 1770; considered a refinement of the heavier, more vigorous Baroque expression; marked by S- and C-curves, tracery, scrollwork, and fanciful adaptations of Chinese, classical, and even Gothic lines; smaller and more delicate in scale than the Baroque

rollers See *staybands*

ropa A garment of Spanish origin from the 16th century, possibly derived from Middle Eastern styles; an outer gown or surcote made either sleeveless or with one of the following types of sleeve: a short puffed sleeve, or a long sleeve puffed at the top and fitted for the rest of the arm's length

rotonde A shorter version of the talma-mantle popular in the Crinoline Period

roundels Circular motifs on tunics

round gown Daytime dress from the late 18th century that did not open at the front to show a petticoat

ruchings Pleated or gathered strips of fabric; used as ornamental trim and especially popular in the 19th century

ruff Wide, separate collar used during the second half of the 16th century and the first decades of the 17th century; often made of lace and stiffly starched

S

sack jacket A loose, comfortable man's jacket with no waistline, straight fronts, center vents in back, sleeves without cuffs, and a small collar with short lapels; originated in the Romantic Period and popular during the Crinoline Period and after; forerunner of the modern sports jacket

sacque An 18th-century gown that was unbelted, loose from shoulder to floor; also called *robe battante*, *robe volante*, and *innocente*

sacred peplos Magnificently patterned garment carried in procession to the temple to be placed upon the statue of the Greek goddess Athena

safari jacket Jacket from the late 1960s and 1970s with peaked lapels, single-breasted front, belt, and four large bellow pockets

sagum A cloak made from a single layer of thick wool, generally red; worn by ordinary soldiers and by citizens in ancient Rome at time of war

sandalis See *solae*

sans culottes Literally meaning "without breeches," was a nickname for revolutionaries who wore trousers (associated with the common people) instead of breeches (associated with the aristocrats) during the French Revolution

santon For women in the Romantic Period, a silk cravat worn over a ruff

scarab Popular motif in ancient Egypt that represented the sun god and rebirth

schenti A wrapped skirt that was a major garment for men throughout all of Egyptian history; its length, width, and fit varied with different time periods and social classes; also called *shent* or *skent*

secret The bottom layer of a women's skirt from the 17th century

segmentae Square or round decorative medallions that were placed in different areas of tunics of the Early Middle Ages

selvage Tightly woven band on either edge of fabric parallel to the warp (lengthwise direction) that prevents fabric from unraveling

sericulture Silk production process, including how the silkworm was bred, raised, and fed; said to have been brought to western Europe from China by two monks in the 6th century

set-in sleeves Sewn-in sleeves, a design feature influenced by military garments during the Late Middle Ages

shawl Woven rectangles or squares of fabric, draped in various ways

shawl-mantle A loose cloak for women during the Romantic Period, reaching almost to the skirt hem

shawl mantlet See *mantlet*

sheath Any straight, narrow, close-fitting dress; seen in many periods with variations in length, fit, and other details

sheath dress In ancient Egypt, a close-fitting women's garment that consisted of a tube of fabric beginning above or below the breasts and ending around the lower calf or ankle that appeared to have one or two straps holding it over the shoulders; in modern times, refers to a tight-fitting dress that follows the line of the body

shent See *schenti*

shepherdess hat See *bergere*

shingle An exceptionally short women's haircut of the 1920s in which the back hair was cut and tapered like that of a man

shirtwaist A woman's blouse styled like a man's shirt with buttons down the front and a tailored collar, and sometimes worn with a black tie; important in the 1890s and revived in subsequent periods; also called *waist*

short gown A garment from the 18th century similar to a loose jacket or overblouse worn with a skirt by working-class and rural women

shorts suit A woman's suit from the 1980s consisting of shorts and a matching tailored jacket, worn as an alternative to the skirted suit

shot fabric Iridescent fabric created by weaving one color in the lengthwise yarns and another in the crosswise yarns

shrugs Bolero-like cardigans from the 1950s

silent generation Post–World War II and Korean War generation of young people

sinus Pocket-like pouch formed from the overfold of the imperial Roman toga

skeleton suit Worn by boys older than 7 or 8 during the 18th and early 19th centuries; consisted of long straight trousers, a white shirt with a wide collar that finished in a ruffled edge, and over the shirt, a jacket that either was a shorter, simplified version of those worn by adults or was cut to the waist and double-breasted

skent See *schenti*

skimmer A-line dress or shift that hangs away from the body

skirt A garment beginning at the waist or slightly below and hanging loosely around the body in varied lengths; in the ancient world and much of the medieval period, worn by both men and women; in later periods and in modern Western fashion, generally worn by women, with a few exceptions; see also *wrapped skirt*

slacks Term usually applied to loose-cut casual pants, not part of a suit

slap soles A flat sole attached to high-heeled shoes only at the front, not at the heel; a feature of some early 17th-century footwear

slashes Cuts in the fabric through which an underlayer of contrasting colored fabric might be pulled; especially popular during the Renaissance Period

sleeper Sleepwear for young children in the form of pajamas with feet

sleeve en bouffant Alternated places of tightness with puffed-out expansions

slip Undergarment developed in the 1920s, beginning above the bust, worn by women and girls, usually held in place with shoulder straps; length is long or short in relation to the dress worn on top

sloppy joes Large, loose pullovers worn by adolescents in the mid-1940s

slops Style of trunk hose that sloped gradually from a narrow waist to fullness concentrated about mid-thigh, where they ended; also called *gallygaskins*; used from the 16th to the 19th centuries to refer to breeches that appeared wide at the knees

smock frock Men's knee-length, loose-fitting homespun gown; worn by farmers in the 18th century; later shortened to *smock*

smocking Decorative needlework from the 18th century used to hold gathered cloth together; the stitches catch alternate folds in honeycombed designs

sneakers Canvas tennis shoes

snood A net worn as a hair covering, frequently made of colored silk or chenille; popular during the Crinoline Period and the period of World War II

soccus A slipperlike shoe reaching to the ankle; worn in ancient Rome

social networking sites Phrase that describes websites that allow users to create their own unique "space" in which they can connect with others. These sites include ones that are business related (e.g., LinkedIn), social related (e.g., Twitter and Facebook), provide location-based services (e.g., Foursquare), and provide visual communication (e.g., Instagram, Pinterest, and Flickr).

solae Simple form of sandal worn by the ancient Romans, consisting of a wooden sole held on with thongs or a cord; also called *sandalis*

soul patch A small patch of hair centered beneath the lip

Spanish farthingale Garment constructed of whalebone, cane, or steel hoops graduated in size from the waist to the floor and sewn into a petticoat or underskirt that provided support to the flared, cone-shaped skirt; first appeared in the mid-16th century; also called *verdugale*

Spanish work Especially fashionable embroidery that originated in Spain and spread throughout the rest of Europe in the 16th century; consisted of delicate black silk figures worked on fine, white linen, often applied to the neck band and wrists of men's shirts and women's chemises

spats Separate protective coverings from the 18th century and after that extended from the top of the shoe to some point below the knee; worn to protect the legs when sturdy shoes were worn outdoors; also called *spatterdashers*

spencer A short jacket worn by both men and women in the 19th century that ended at the waistline, made with sleeves or sleeveless; the color usually contrasted with the rest of the costume

sports jacket Conventional tailored jacket made in tweed, plaid, or plain colors; worn with contrasting pants for business and general wear; when these were first developed, American tailors called them casual jackets or sack jackets, while the British preferred the term *lounge coat*

sportswear Originally worn for tennis, golf, bicycling, bathing, ice skating, yachting, and hunting; now synonymous with *casual wear*

staybands During the 17th century, thick corded or quilted material that was tied tightly around the body of children, probably intended to prevent umbilical hernias or to promote an upright posture; also called *rollers*

stays British English term for *corset*

steinkirk A style of the cravat from the 18th century in which the tie pulled through the buttonhole and twisted loosely

stephane Ancient Greek bridal crown

step-ins Women's underpants with widely flared legs and narrow crotch, popular in the 1920s and 1930s

Stetson hat Developed by John B. Stetson, after he travelled in the American west during the mid-19th century, this was a broad-brimmed, high-crowned felt hat made of beaver and rabbit skins. Cowboys adopted this practical, water-repellent, wide-brimmed, crushable hat, and Stetson began to manufacture these hats upon his return to New Jersey.

stock A linen square used in the mid-18th century that was folded to form a high neckband, stiffened with buckram, and fastened behind the neck

stola Garment reserved for free, married women of ancient Rome that denoted status as *mater familias*; scholars disagree on its construction; see also *instita*

stole During the Early Middle Ages, a long, narrow strip of material that clergy wore over the shoulder during the mass; after the Directoire Period, referred to shawl made in square or oblong shape. In contemporary fashion, generally refers to long narrow shawl made of any material and worn over the shoulders.

stomacher First used in men's doublets in the 16th century (also called a *paltock* in England), later with women's corsets and dresses; garment was cut with a deep V at the front, and a filler or stomacher of contrasting color was inserted under the V, extending to the waist or beyond; separate stomachers could be tied or pinned to the front to vary the garment's appearance

straight soles Footwear made without shaping for left or right feet

straw boater Men's flat-topped, flat-brimmed hat with an oval crown; also worn by women for sportswear or during work; first appeared in the late 19th century

street styles Term coined in the 20th century to describe counter-culture dress of adolescents, such as the zoot suit and the clothing worn by the Teddy Boys and the beatniks. Although street styles were intended to make a statement about being different from mainstream, these fashions also provided new ideas for the fashion industry.

strophium Female undergarment band of fabric used in ancient Rome that supported the breasts

style The predominant form of dress of any given period or culture

style tribes Groups that followed styles that diverged from mainstream fashion; they emerged in the 1960s and 1970s

subligar Loincloth undergarment for middle- and upper-class men, and a working garment for slaves in ancient Rome

subligaria Loincloth undergarment for women in ancient Rome; feminine form of *subligar*

sudarium A white linen handkerchief used in ancient Rome for wiping off perspiration, veiling the face, or holding in front of the mouth to protect against disease

sugar loaf hat See *copotain*

sumptuary laws Laws restricting the ownership and use of luxury goods to certain social and/or economic classes; such laws were frequently applied to clothing and its ornamentation, but were rarely obeyed or much enforced

supportasse or supertasse Frame that supported ruffs of enormous widths during the 16th century; also called an *underproper*.

surcote French word for outer tunic; more widely used than *under tunic* by costume historians when writing about periods after the 13th century

surrealism A literary and arts movement beginning in the 1920s that depicted unconventional subjects and drew on the subconscious imagination

surtouts Garments from the late 17th century with fitted straight sleeves, turned-back cuffs, and a buttoned-down front; they completely covered the breeches and waistcoat; also called *justacorps*

swaddling clothes Bands of fabric wrapped around an infant's body, thought to prevent deformity of children's limbs; common practice throughout Europe and North America until the 19th century; also known as *swaddling bands*

sweatshirt Long-sleeved, fleece-backed, cotton knit pullover or zipped-front knit shirt made with rib-knit crew neck, rib-knit cuffs, and waistband; sometimes has attached hood and often is worn with matching sweatpants; first appeared in the 1970s

swirl skirt A skirt made from bias-cut strips of multicolored fabrics that were often imported from India; popular in the 1970s

Swiss belt A wide belt popular in the Crinoline Period, sometimes enclosing the rib cage, frequently laced up the front in a manner similar to a peasant's bodice

synthesis Lightweight garment worn by Roman men at dinner parties instead of the toga because the toga was too heavy and cumbersome to wear when the ancient Romans reclined to eat

T

tabard Originally a short, loose garment with short or no sleeves that was worn by monks and lower-class men in the Early Middle Ages; in some instances, it fastened for only a short distance under the arms either by seaming or with fabric tabs. In later centuries this garment became part of military dress or the dress of servants in lordly households.

tablion Large, square decorations, in contrasting colors and fabric, that were located at the open edge over the breast on cloaks from the Byzantine Empire

tailclouts English term for a *diaper*; also called *nappies*

tailored dress Pieces are cut and sewn together; they fit the body more closely and provide greater warmth than draped garments

tailor-made A women's garment from the 1890s for morning or country wear, usually a suit consisting of a jacket and skirt made by a tailor rather than a dressmaker

talma-mantle A full cloak with tasseled hood or flat collar popular during the Crinoline Period

tank top Similar to an *athletic shirt* but more likely to be made in colors

tarbush High, brimless hat shaped like a truncated cone, similar to the fez; worn in southwest Asia or northern Africa

tea gown Long, informal hostess gown in pale colors worn from 1877 to the early 20th century; usually made of thin wool or silk, it could be worn loose-fitting and worn without a corset

tebenna Rounded mantle worn by Etruscan men and women, woven with curved edges in a roughly semicircular or elliptical form and worn draped in various ways

teddies Straight-cut garments of the 1920s, combining a camisole with a short slip, or long vest with underpants; a wide strap is attached to the front and back at the hem, thus making a separate opening for each leg. Now refers to a one-piece, tight-fitting minimal garment with a low-cut front and back and high-cut leg opening.

Teddy Boys Working-class British adolescents in the 1950s who adopted styles in menswear that had a somewhat Edwardian flavor: longer jackets with more shaping, high turned-back lapels, cuffed sleeves, waistcoats, and well-cut, narrow trousers

Tencel® Regenerated cellulosic fiber made by a more environmentally friendly process than rayon

tête de mouton An 18th-century women's hairstyle achieved by close, tight curls

Theatre de la Mode An exhibit of miniature mannequins, 27 inches tall, that were displayed on a miniature set in 1944 as a travelling exhibit that showed the latest fashions from the haute couture; not only featured the work of more than 40 French couturiers, but also raised funds for war relief

theme A recurring or unifying subject or idea

thong Designed in 1975, variously described as a "virtually bottomless bathing suit" or a "glorified jockstrap," cut to reveal as much of the buttocks as possible while covering the crotch; now a common cut for underwear

tippet Narrow fur or feather piece from the 18th century that was worn around the shoulders like a modern-day stole

toga Semicircular draped garment symbolizing Roman citizenship, worn by men and free Roman children; see *toga praetexta* for toga used by children

toga candida Toga lightened to an exceptional white shade and worn by candidates for office in ancient Rome; the word *candidate* derives from this term

toga picta Purple toga with gold embroidery, assigned on special occasions to victorious generals or other persons in ancient Rome who distinguished themselves in some way

toga praetexta Toga with a purple border worn by the young sons (until age 16) and daughters (until age 12) of the ancient Roman nobility and by certain adult magistrates and high priests

toga pulla Black or dark-colored toga, said to have been worn for mourning in ancient Rome

toga pura Plain white, undecorated wool toga worn after the age of 16 by the ordinary male ancient Roman citizen

toga trabea Multicolored, striped toga assigned to augurs (religious officials who prophesied the future) or important officials in ancient Rome

toga virilis See *toga pura*

toga with folded bands Style in which the overfold was folded back and forth upon itself until a folded band of fabric was formed at the top of the semicircle

tonsure Distinctive haircut worn by priests in the Early Middle Ages

topcoat A type of lightweight overcoat

top hat Men's tall hat made of shiny silk or beaver cloth with a narrow brim; first developed toward the end of the 18th century as part of men's riding costume; was the predominant hat style during the Directoire Period, and remained so for formal occasions throughout the rest of the 19th century

topper coat Woman's hip-length coat, often made with a flared silhouette, popular in the early 1940s

toque High, brimless hat especially popular in the early 19th century

toupee 18th-century French term for brushing the hair straight back from the forehead and into a slightly elevated roll; also called a *foretop*

trapeze Unfitted dress with narrow shoulders that gradually grows to a very wide hem, somewhat like a pyramid; introduced in the late 1950s

trench coat A water-repellent coat of closely woven cotton twill, belted at the waist; became a standard item for men after World War I, and after several decades, was also adopted by women

trickle-down theory of fashion The idea that fashion changes result from the initial adoption of new and innovative styles by the upper socioeconomic classes, and the subsequent imitation of these styles by the lower socioeconomic classes; see also *bottom-up theory of fashion*

tricorne Term coined by costume historians for a variation of the cocked men's hat, turned up to form three equidistant peaks with one peak in the center front; worn in the 18th century

trilby Man's soft felt hat with supple brim

trousers In modern usage, a bifurcated (two-legged) garment worn by men or women; term sometimes used interchangeably with *pantaloons*. In the early 19th century, these were usually close-fitting pants for men with an ankle strap or slit that laced to fit the ankle.

trucker's cap A variation of the baseball cap that had a foam section at the front of the crown and mesh around the rest of the cap

trunk hose Breeches worn by men in the mid-16th century that were joined to nether stocks; ranged in size from very wide and padded to very small and worn with tight-fitting hose

T-shirt Originally white, knit undershirts worn by men in the 1930s that featured round necks and set-in sleeves; eventually found their way into general sportswear

tuckers See *chemisettes*

tunic Simple, one-piece, and often T-shaped garments with openings for the head and the arms, usually long enough to cover the torso; in contemporary usage, for women's clothing often means an upper layer of at least hip length worn over pants or a skirt

tunic suit A 19th-century jacket fitted to the waist, attached to a full, gathered, or pleated skirt that ended at the knee; buttoned down the front, often had a wide belt, and was usually worn with trousers; some versions for small boys ages 3 to 6 combined the tunic jacket with frilled, white drawers

turban Traditionally, a men's headdress consisting of a long scarf of linen, cotton, or silk wound around a small cap or directly around the head; in more recent times, a woman's version is a close-fitting hat material wound around a small inner cap or a hat constructed to look like a man's or woman's turban

Turkish trousers Middle Eastern dress that served as the basis of trousers used in the bloomer dress. See also *bloomer dress.*

turtleneck jersey Gained popularity for a time as a substitute for shirts and ties when, in 1924, actor Noel Coward initiated the style; popular again in the 1960s and after

tutulus A high-crowned, small-brimmed hat worn by the Etruscans; in ancient Rome, referred to a special hairstyle where the hair is drawn to the top of the head and wrapped in *vittae*, designating the status of *mater familias*

tuxedo Man's semi-formal suit for evening with fingertip length jacket; originally made in dark colors or with a white jacket for summer but now made in a variety of colors; may have originated in Tuxedo, New York in the late 1800s

tweens A new segment of the children's market that emerged by the 2000s and consists of ages 7 to 14

twin set Matching cardigan sweater and pullover sweater

U

ulster A long, almost ankle-length men's or women's coat from the late 19th century with a full or half belt and sometimes a detachable hood or cape

umbo Created by pulling a clump of fabric up from the first and invisible part of the Roman toga that had been placed vertically from floor to shoulder; may have helped to hold the toga drapery in place, but seems ultimately to have become a decorative element

underproper See *supportasse or supertasse*

union suits Combinations used by men and women in the late 19th century that united drawers and under-vests into one garment

unisex clothing Garments first appearing in the late 1980s designed to be worn by either men or women

unitard A one-piece bodysuit from the 1980s made of patterned, knitted fabric that combines leotards and tights into one suit

upper stocks Section of men's hose that in the 16th century was sewn together with the nether stocks; eventually took on the appearance of a separate garment, and was cut somewhat fuller than the lower section; see also *breeches*

upsweep Popular 1940s women's hairstyle with medium-long hair brushed upward from the sides and nape of neck, then secured on top of the head in curls or a pompadour

uraeus Sacred cobra, symbol of royal power in ancient Egypt

V

veil Cloth rectangle, smaller than either a shawl or a cloak, worn by women to cover the head and sometimes part of the body

Venetians Skin-tight version of breeches from the late 16th century, wide at the top and tapering to the knee

verdugado See *Spanish farthingale*; also spelled *verdugale*

vest Garment adopted by King Charles II of England in 1666 that consisted of a knee-length outer coat and a waistcoat of the same length that obscured the breeches beneath; in subsequent centuries, referred to the combination of an outer coat (the cut of which varied), a sleeved or sleeveless waistcoat (of varying lengths), and breeches or trousers that became a basic costume for men. In contemporary fashion, the term refers to a sleeveless garment, buttoned down the front, and usually worn over a shirt or a blouse, and if part of a three-piece suit, worn under the outer jacket.

Victoria sleeve A variation of the sleeve en bouffant with a puff at the elbow; popular during the Victorian Period

vintage clothing Term coined in the late 20th century for clothes and accessories from another fashion period refurbished and sold in department stores or specialty shops

virago sleeves Stylish sleeves that were paned and tied into a series of puffs; popular during the 17th century

virtual Internet sites Internet sites consisting of imaginary environments that participants can develop and where they can create a character representing themselves, called an *avatar*

vitta A woolen band used by matrons in ancient Rome to bind hair; plural *vittae*

W

waistcoat See *vest*

walking dress See *day dress*

walking shorts Shorts ending just above the knee; based on military costume of British Colonial soldiers, adopted in the 1930s by the well-to-do for vacation wear, and revived in the 1950s as general sportswear for men and women; also called *Bermuda shorts*

Wallace Beery shirt Styled like a *henley shirt*; made popular when worn by actor Wallace Beery in the 1930s

warp Yarns that run lengthwise in woven fabric

wash-and-wear Easy-to-care-for fabrics that did not require ironing, first developed in the late 1950s

wash ball A combination of rice powder, flour, starch, white lead, and orris root used in place of soap during the 18th century

Watteau back A 19th-century term for loose-fitting, pleated-back styles of the type used in the gown called *robe à l'Anglaise* in the 18th century

wearable art Beginning in the 1970s, a garment created as a unique work of art; fiber artists combine a variety of techniques such as crocheting, hand weaving, and slashing, as well as feathers, beads, and ribbons

wedge Cut in which the hair is tapered close to the head at the nape of the neck, above which the hair is full and all one length; the front and sides are all one length, squared off at the middle of the ear, and short bangs are informally styled; became popular in 1976 after Olympic medal–winner Dorothy Hamill wore the style at the Olympic games

weejuns Moccasin-type shoes introduced in the 1930s, adapted from shoes worn by Norwegian fishermen

weft See *filling*

weighting A process used to give silk fabric greater body, in which silk was treated with metallic salts, first used in the late 1870s; excessive weighting damaged fabrics, and by the late 1930s, legislation set limits on how much weight could be added

western dress Style of dress prevalent in western Europe and Euro-America since the Middle Ages

western shirt See *cowboy shirt*

wheel farthingale See *French farthingale*

wheelys Shoes from the 2000s with wheels set into the soles

whisk A wide lace collar or band of linen from the late 17th century

white bucks White buckskin shoes whose popularity in the 1950s is directly attributable to television

white crown Worn by Egyptian pharaohs to symbolize rule over Upper Egypt

wide awake A cap with a low crown and wide brim and made of felt or straw, popular during the Crinoline Period

wifebeaters Tops cut like men's athletic shirts; Marlon Brando wore one when he played a violent working-class husband in the play and film *A Streetcar Named Desire*

wimple A fine white linen or silk scarf from the Early Middle Ages that covered the neck; the center was placed under the chin and each end pulled up and fastened above the ear or at the temple; generally worn in combination with a veil

winkle pickers Men's shoes with exaggeratedly pointed toes; popular with the Teddy Boys from the 1950s

winter mantles From the Early Middle Ages, mantles for outdoor wear; could be lined with fur

woad Readily available natural blue dye used in the Middle Ages

wrapped skirt In ancient cultures, cloth wrapped around the waist; major garment for men in Egyptian history, with length, width, and fit dependent on time period and social class. In Minoan culture, it was worn by both men and women; in Egypt, also called *shent* or *skent*; see also *skirt*.

wrappers Dressing gowns for women worn in the 18th century; applied subsequently to wraparound robes

Y

yuppie A nickname from the 1980s applied to young, upwardly mobile professionals who work in fields such as law and business; male yuppies wore Italian double-breasted "power suits" to work, and female yuppies donned similarly cut women's versions

Z

zeitgeist The specific expression of an era determined by a complex mixture of social, psychological, and aesthetic factors; spirit of the times

zip-in lining A feature from the 1930s that made cold-weather coats convertible to be used in warmer temperatures

zipper A toothed slide fastener first mass-produced in the 1920s by B. F. Goodrich; adjective used to describe apparel in which a zipper is a prominent feature

zoot suit An extreme form of the sack suit with a long jacket, excessively wide shoulders, wide lapels, and markedly pegged trousers; originated in the 1940s, some say with Mexican American immigrant workers (called *pachucos*) in southern California, while others claim it was first worn by an African American bus driver in Gainesville, Georgia

zouave Short, collarless jacket, trimmed with braid and often worn over a garibaldi shirt during the Crinoline Period

CPSIA information can be obtained at www.ICGtesting.com
Printed in the USA
LVOW03s0238230515

439582LV00012B/195/P